CHAUTAUQUA

An American Utopia

CHAUTAUQUA

An American Utopia

Jeffrey Simpson

with photographs by
Paul Solomon

Harry N. Abrams, Inc., Publishers
in association with
The Chautauqua Institution

FOR ALFREDA IRWIN

Front cover: A chamber music group plays on Bestor Plaza.
Back cover (clockwise from upper right): An art student paints
by the lakeshore; a Chautauquan and her daughter on the porch
of their Miller Park cottage; a Chautauqua street scene; people gather
before an opera performance at Norton Hall; sailing on Chautauqua
Lake; flutists play in a Chautauqua Symphony Orchestra concert.

Page 1: Some say the oldest Chautauqua cottages, like this one with
a porch from 1879, are built on platforms put down for the tents
of the earliest days of the assembly.
Pages 2–3: A chamber music group plays on Bestor Plaza.
Pages 6–7: An aerial view of Chautauqua.
Page 8: The Chautauqua Belle is a stern-wheeler excursion boat,
created in imitation of the old lake steamers.
Page 127: The Miller Bell Tower, designed in Tuscan style
and dedicated in 1911 in memory of Lewis Miller, is the symbol
of The Chautauqua Institution. It stands on Fair Point, where the
Chautauqua founders landed to establish the first assembly.

Right: A Chautauqua street scene shows the tiers of porches that make
life on the Grounds typical both of old-fashioned America and also of
traditional European cities, where people gather in communal public
spaces as much as they do in their homes.

PROJECT MANAGER: Diana Murphy
EDITOR: Sharon AvRutick
DESIGNER: Judith Michael

LIBRARY OF CONGRESS
CATALOGING-IN-PUBLICATION DATA
Simpson, Jeffrey.
Chautauqua: an American utopia / Jeffrey Simpson;
with photographs by Paul Solomon.
p. cm.
Includes bibliographical references and index.
ISBN 0–8109–2608–3 (pbk.)
1. Chautauqua Institution—History. I. Title.
LC6301.C5S56 1999
378.747'95—dc21 98–42811

HARRY N. ABRAMS, INC.
100 FIFTH AVENUE
NEW YORK, N.Y. 10011
www.abramsbooks.com

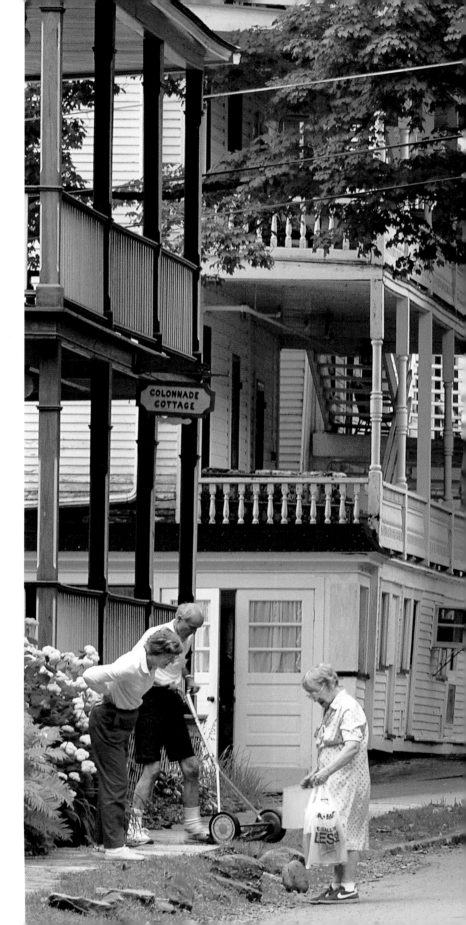

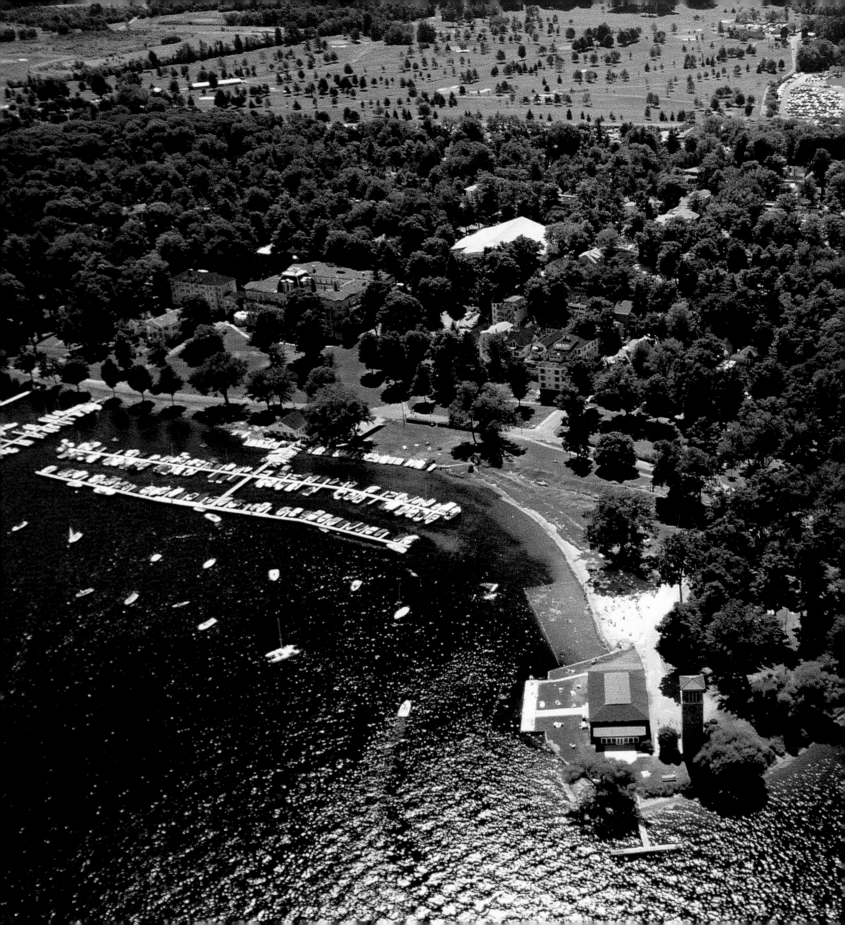

CONTENTS

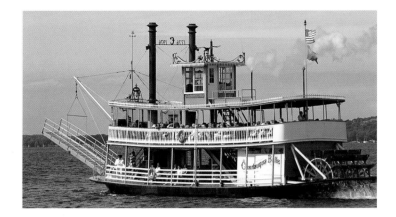

As with few other institutions I know, Chautauqua draws from and expresses allegiance to its rich and unique history. It is a history of a place built on a dream, a vision held by two remarkable people, Lewis Miller and John Vincent. Through 125 years, that which shaped the founding of this place—a commitment to education and opportunity, to Vincent's credo that "every man has the right to be all that he can be"—has shaped its development. We are fundamentally about the same mission that gave us birth.

Concurrently, we are not held captive by this history. Chautauquans have always emulated our founders' capacities to envision ways to take the Institution to new and greater levels of expression of its mission.

It has not always been an easy journey. Chautauqua has known its difficult moments, but good times and bad, the Institution has never lost sight of its history and heritage. Armed with this inspiration, Chautauqua has now reached the milestone of 125 years of a truly remarkable life.

My thanks to Jeffrey Simpson for capturing it in the pages you are about to read.

Daniel L. Bratton, President
The Chautauqua Institution

PREFACE

When the Chautauqua board of trustees and its president, Daniel Bratton, asked me to write a history of the Institution for its 125th anniversary in 1999, I was honored and touched. Much of my life I have been a writer, and all of my life I have been a Chautauquan. Chautauqua occupies a large part of my thinking life and from time to time a part of my writing life, so to have the chance to do this for the Institution, and to have a chance to explore Chautauqua from the perspective of its total history was a privilege indeed.

Musing over ideas I'd written down years ago, I decided that I would start by trying to think through my own conflict about the two Chautauquas I always see in my mind. One is the community I see very colorfully before me when I am there. This is the bustling, young, vital Chautauqua of today—the program bursting the bounds of every hour, the buildings multicolored, gleaming, and quaint only in their intention to be so.

The other vision is the kindly, sleepy, rather shabby Chautauqua of my childhood, magical when I rode through it on my bicycle and spent long hours in the children's library. (I refused to go to Boys' Club, the day camp for children between the ages of six and fifteen, but redeemed myself slightly by winning a prize for spending more time in the children's library than any other child since it opened.)

This Chautauqua was filled with eccentric characters: There was an old man working with my father on the Main Gate (the entrance to this enclosed Shangri-La community) who rubbed street signs to see if the letters were raised and talked about the Stuart kings of England; there was Jessie Mockel, who drilled the opera chorus like a grenadier and who looked just like my great-aunts, except that she smoked (which shocked my aunts terribly). We'd often see her in the Glen Park Cafeteria line beside the very long picture of Eleanor Roosevelt entertaining the Chautauqua Women's Club at the White House; it stretched from the silverware tray to the tomato aspic, the first dish in the salad counter that one finally, gratefully— despite its peculiar nature—came to.

And there was old Mrs. Fishberg, whose husband, the brother of first violinist Mischa Mischakoff (why were their names different? I wondered), also played in the symphony, and who one long afternoon spread out for me on her bed all the heirloom jewelry that she had taken with her when she escaped from Russia. She and the jewels had all hidden under the straw in a hay wagon, she said.

This was the Chautauqua where it was said that "old ladies brought their mothers." It was a kind, serene idyll, a sort of Chekhov play where private dramas were played out in an atmosphere of wicker and ennui. The program

Churchgoers take refreshment on the porch of the United Methodist House, built in 1888, after the Sunday morning service in the Amphitheater. Most Protestant denominations as well as Roman Catholics have houses on the Grounds for their clergy and church members. The Chautauqua Hebrew Congregation holds weekly services.

was as rich as ever in its content, but it was a feast that had satiated the celebrants. After the Depression, the Institution went through thirty years of holding the line. Inertia was the rule of the day at Chautauqua. The fact that nothing changed seemed a virtue in itself, lacking the option of change for the good.

But, in fact, this Chautauqua was only two generations away from its innovative and vigorous beginnings. In a ceremony used at the commemorative Old First Night, the leader of the evening always asked who was there who had been at the first evening in 1874. Until a nonagenarian, Mr. Royal Blodgett of Jamestown, New York, stood and tipped his hat for the last time in the early 1960s, there always was someone.

Thinking about it now, I see Mr. Blodgett's presence as a metaphor for the fact that Chautauqua's history had faded to no more significance than a personal memory as the national life moved ahead and left it behind. Nostalgia is the product of personal memory; it is an expression of fond regret for time lost, but Chautauqua is too big to be a subject for mere nostalgia. It should belong to history itself—the larger ordering of human experience that enables us to recapture and learn from times gone by.

By the early 1970s, it was discovered that the one long lifetime that seemed to mark Chautauqua's boundaries was running out. The force that was going to stop the inertia of the leisurely repetition of the seasons turned out to be decay—the organic loss of wood and brick and fabric to time. The buildings, the very physical Chautauqua that held us rapt (and wrapped) in illusion each year, were not going to be around much longer if something wasn't done. A newly revitalized leadership began campaigns to raise funds, to strengthen the programs and the buildings that housed them.

So vitality was assured. Chautauqua not only survived; it triumphed. It has moved from being one or two closed episodes in textbooks to participating in the continuum of American life—an ongoing part of history itself.

The physical presence of Chautauqua is a symbol of this relation to history. It is not just a Shangri-La preserved by nostalgic private memories. The best aspects of Chautauqua from the past—buildings, program elements, traditions, and rites—we preserve as an acknowledgment that our current good life is part of the flow of the American experience.

I still sometimes regret the passing of those gentle old days, and I would be sorry to see today's energy iron out all the quirks and odd corners and creative woolgathering that belonged to the Chautauqua of my memory, but there is no doubt in my mind that it is today's energy and new life in combination with the old that makes it the national treasure that it is.

And as for those kindly ghosts of memory . . . perhaps on a shady porch in the depth of the afternoon or during a rehearsal in a dim corner of the Amphitheater, there is still a place for them.

Opposite: Friends chat on the porch steps of Alumni Hall, a Queen Anne–Style building erected in 1892 for the CLSC alumni and festooned with the 118 banners made by graduating classes.

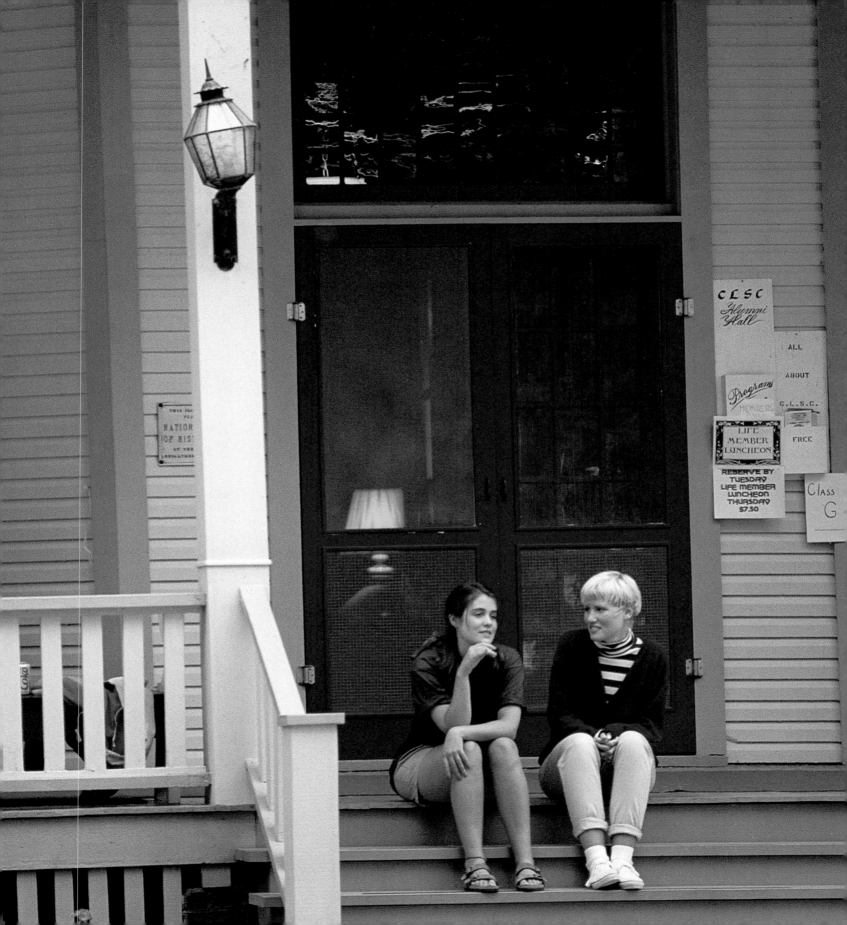

ACKNOWLEDGMENTS

First, I would like to thank Richard Redington, vice president for education and planning for The Chautauqua Institution, for his erudition, good humor, restrained editing, and unfailing support during the time that we worked on this project together.

I would also like to thank William Karslake, chairman; the board of trustees; and Daniel Bratton, president of The Chautauqua Institution, for asking me to undertake the writing of this history.

The entire senior staff has been extraordinarily supportive in every way for the duration of the work, as well as offering friendship and a flattering engagement in the affairs of the Institution for years before that. Specifically, my thanks go to Joseph Johnson, vice president and treasurer, for his herculean efforts on the business and legal side of the project; Thomas Becker, vice president for development; Ross MacKenzie, director of the department of religion; Charles Heinz, vice president for administrative and community services; and Marty Merkley, vice president for programming, for their encouragement.

Joan Fox, in the office of Institution relations and public affairs at Chautauqua, has been both enthusiastic and patient, and her staff has been long-suffering with my sometimes inchoate requests for photographic material. Carol White, assistant to the president, is a longtime friend whose interest in the project never faltered.

June Miller-Spann, archivist of The Chautauqua Institution, was unfailingly informed, helpful, and efficient during my work with the archives.

Two longtime Chautauquans and invaluable friends who contributed interest, anecdotes, and prodding when necessary were Mary Frances Bestor Cram and Sylvia Faust. I would also like to thank lifelong Chautauquans Isabel Pedersen, Robert Osburn, and Samuel M. Hazlett III for sharing their memories.

Richard Miller, former chairman of the board of trustees of The Chautauqua Institution and former chairman of the Chautauqua Foundation, shared his memories, his analyses, and his records with me.

Finally, no work about Chautauqua history would be possible without the devotion to Chautauqua, encyclopedic knowledge of its history, and completely unselfish willingness to share it, of Alfreda Irwin, historian of The Chautauqua Institution.

At Harry N. Abrams, I have to thank Paul Gottlieb, president, who has been a friend for more than twenty years and with whom I have discussed this project many times, for helping it finally come to fruition. Diana Murphy was the editor who originally saw the possibilities for the project; I treasured her good humor. Dana Sloan, the designer at an early stage, showed a wonderful appreciation of the visual material. Liz Robbins, director of publicity, has also been cheering on my efforts for many years. Judith Michael has done a wonderfully professional job in making Chautauqua come alive visually on the page. And finally, Sharon AvRutick's tough, fair editing, willingness to engage in dialogue, and appreciation of the absurd has made me grateful to find not only a superb colleague but a new friend.

Higgins Hall, the location of the Chautauqua Cinema, is the building where President Theodore Roosevelt was entertained in 1905.

Enthusiasts debate a point outside an afternoon lecture in the Hall of Philosophy.

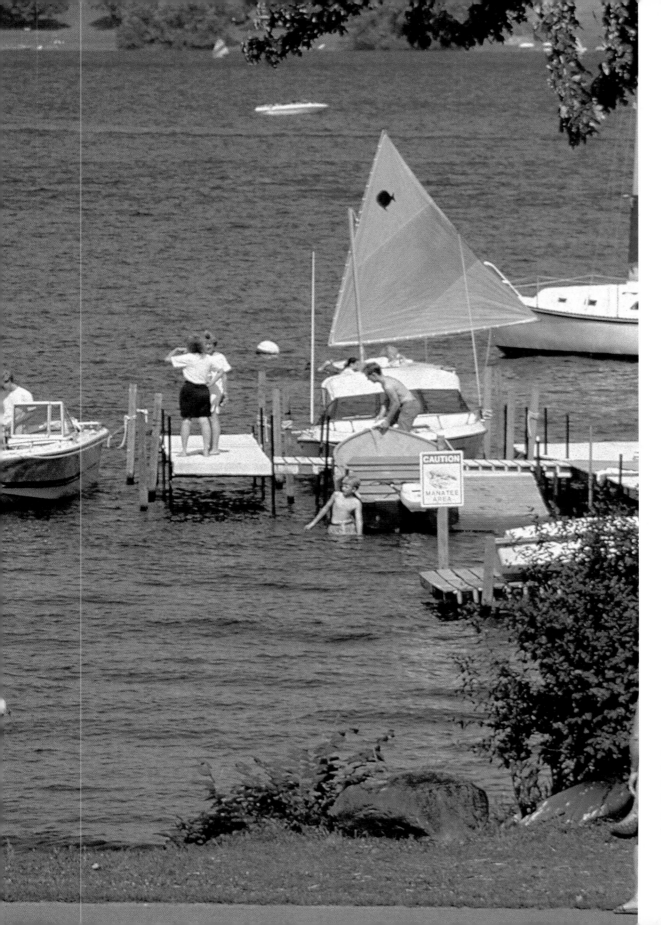

Sailing on the lake is part of Chautauqua's recreational aspect. The Chautauqua Yacht Club holds races each weekend.

Utopia by the Lake

Looking back in 1885, Dr. Vincent would state that there had been "a hunger of mind abroad in the land." He—John Heyl Vincent, a minister in the Methodist Episcopal Church—was writing in western New York on a cottage porch that was sheathed in striped tenting. This confection of a dwelling stood in a lakeshore row of Victorian summer cottages bedecked with wooden gingerbread; a roofed open-air amphitheater, looking like the biggest revival tent ever, was set into the hillside near-by; and a grand clapboard hotel sprawled majestically along the shore. The picture-book small town was Chautauqua; and Dr. Vincent was describing what the community meant beneath its dress of summer festivity to a country hurtling into an industrial and technological future from a war-torn past. Chautauqua would satisfy a widespread yearning for cultural life. It was the center of a nationally renowned educational movement that Vincent, with an Akron, Ohio, inventor named Lewis Miller, had founded in 1874. It would give moral and intellectual guidance to Americans for years to come.

Today The Chautauqua Institution, as the community is officially called, is a collection of about twelve hundred Victorian cottages, contemporary houses, condominiums,

Opposite: Chautauqua cottages surrounding Miller Park, the oldest part of the Grounds, jostle companionably together.

hotels—big and small—shops, and public meeting halls, covering 225 acres along the shore of Chautauqua Lake in the westernmost part of New York State. Ten thousand years ago, glaciers gouged out the state's Finger Lakes. Chautauqua Lake is one of them, though, near Lake Erie, it is a hundred miles west of the others. The community's townlike campus is called the Grounds, and during the winter there are about four hundred people there, but for nine weeks in the summer the population swells to nearly eight thousand at any one time. Over the course of the summer, nearly 150,000 people come from all over the United States, Canada, and Europe to attend symphony and chamber-music concerts; lectures and sermons; opera, theater, and ballet performances; jazz and rock concerts and cabaret; and summer school. Through those weeks, known as the Season, there is an admission charge to enter the Grounds, but anyone can buy a ticket for almost any fragment of time—a half day, an evening, a week, or the whole nine weeks. Once visitors have entered the Grounds, they are free to attend most of the programs, which take place either in the five-thousand-seat, roofed open-air Amphitheater or in one of the open pavilions dotted among the groves and cottages. Car access is strict-ly limited during the Season, so for that period Chautauqua becomes a community on foot.

And community it is—both in the physical sense of a

A potter working in the Arts and Crafts Quadrangle continues a long tradition of the fine arts at Chautauqua. Currently, the art school is directed by Don Kimes.

and values for well over a century. "Chautauqua is part of the American imagination," said Pulitzer Prize–winning historian David McCullough, giving the first Chautauqua Lecture, in 1993. "It belongs with Concord, Massachusetts, or Hannibal, Missouri, or Springfield, Illinois, as one of these places that help define who we are and what we believe in. It has its own mythic force."

Nine American presidents have spent time at Chautauqua; opera singers, bandleaders, revivalists, aviators, and diplomats have sung, performed, and orated there. Theodore Roosevelt called it "typically American, in that it is typical of America at its best"; George Gershwin wrote his Concerto in F at Chautauqua; Amelia

Opposite: An art student paints by the lakeshore.

A student at the Chautauqua School of Art, where classes range from representational painting to avant-garde work in several media.

place in which people share their lives and in the general sense of representing shared interests and values. Chautauqua draws on the deep American tradition of the town as a planned community built by people with a common philosophy who want to live out and perpetuate their ideals. Starting with Puritan governor John Winthrop, who wrote in 1630 that he wanted the Massachusetts Bay Colony to be "a city set upon a hill to shed a light unto the world," there has been a sense in America that a community should improve the spiritual and mental life of its inhabitants as well as house them. Groups as diverse as the nineteenth-century Utopian communities, the hippie communes of the 1960s, and the new Disney-sponsored city Celebration have attempted to set an example with their shared lives. At times this attitude has seemed to inform the whole of American society and our relations with the world beyond our shores.

Chautauqua, founded with the specific purpose of adult education, has been a beacon of American culture

A piano student practices in one of the little shingle practice shacks located in their own grove.

The piano village, built in the 1910s, contains practice houses, each equipped with its own instrument.

Pages 22 and 23: The Chautauqua Symphony Orchestra plays in the Amphitheater, conducted by Music Director Uriel Segal.

Earhart landed her plane on the community's golf course; FDR made his "I Hate War" speech there; and President Clinton practiced for the debates of his 1996 presidential campaign at Chautauqua. In 1986 an early move in the Soviet Union's glasnost effort involved 250 Chautauquans going with American entertainers and State Department speakers to the Soviet Union to hold "a chautauqua." A similar contingent of Soviets was entertained on the Grounds at Chautauqua the next year, leading to two more conferences. Through it all, individuals and families learning, participating, and improving themselves—and then passing it on—has been what Chautauqua was about. "Now the doctrine which Chautauqua teaches is this," wrote Dr. Vincent in 1885: "that every man has a right to be all that he can be."

Physically, Chautauqua has the appearance of a tightly knit small city behind a fence. Because the original lots were designed for tents or cottages, the center of town, with streets forming a rough grid cut through by leafy ravines, tends to be at two-thirds scale—in fact, the streetscapes almost give the feeling of a movie set. The closeness of the old cottages to each other and to the narrow streets, with the imposing Amphitheater and smaller pillared pavilions scattered among them, makes Chautauqua seem urban in miniature. People staying at Chautauqua live in public spaces—porches, the town green, the Amphitheater—as much as they live in their homes. This situation is classically urban, in the tradition of cities such as Paris and Florence where people tend to spend much of their time in open squares, cafés, and concert halls. Every domestic architectural style used in America between 1875 and World War II can be seen at Chautauqua, along with such public styles as the turn-of-the-nineteenth-century City Beautiful movement, which prescribed formal outdoor spaces and neoclassical buildings. At Chautauqua this is represented by formal allées of trees and neoclassical meeting halls based on Greek and Roman temples.

The quality of being urban in miniature points up a playful element in the Chautauqua atmosphere that is as essential as the seriousness of its program and its ideals. It was the inspiration of the founders, who began the Institution as a two-week educational program for Sunday School teachers, to situate their gathering in a pastoral setting that would involve relaxation as well as instruction. On one level, Chautauqua has always been a summer resort. Today there are two eighteen-hole golf courses (the earlier one was designed between 1913 and 1924, partly by famed golf-course architect Donald Ross), a day camp for children, tennis courts, three beaches, and docks for more than five hundred boats.

Chautauqua's history, to give a précis, falls into four periods. From its founding in 1874 to about 1925, Chautauqua functioned as a national podium. Because of its reading club—the first in America—the prominence of its speakers, and the extraordinary matching of its goals and programs to the preoccupations of mainstream America of the time, the name was a household word from the Allegheny Mountains to the Rockies and beyond. In the 1920s—all at once—the automobile, the movies, and the radio removed Chautauqua's podium function, and the Institution moved into its second phase. Arthur Bestor, Chautauqua's president from 1915 to his death in 1944, was a brilliant program strategist, and his solution to the Institution's diminished national effect was to expand Chautauqua's program internally, thus creating the nation's first arts festival. During the Depression, Chautauqua had financial troubles, like the rest of the nation; and after being saved from receivership in 1936, the Institution entered its third period—thirty-five years of dormancy. Thousands of people still flocked to the grounds each summer; the program continued, as varied as ever; and platform speakers still debated the issues of world hunger and atomic weaponry. But the public buildings decayed, with Band-Aid repairs holding them together from year to year, and any program component that

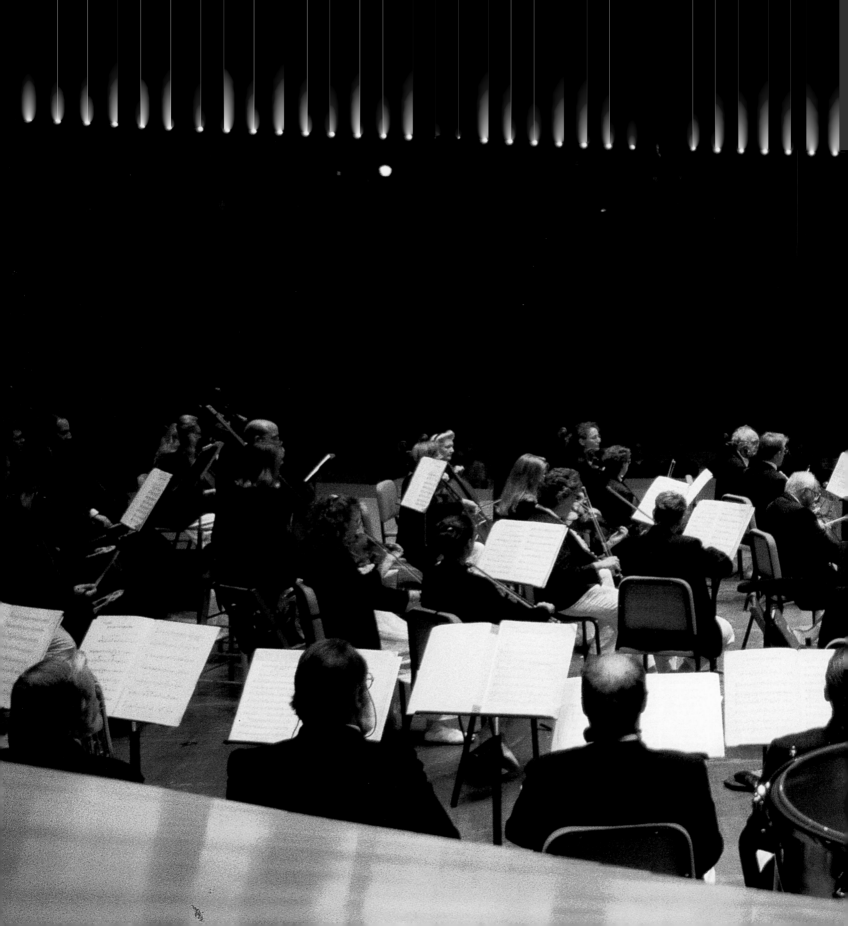

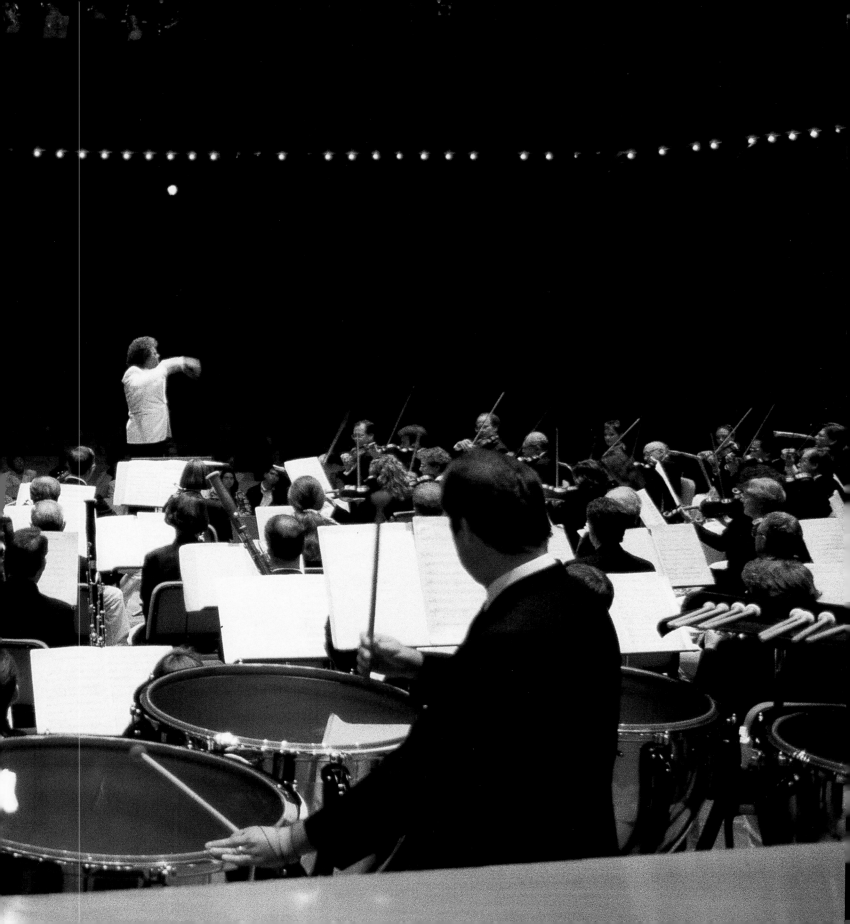

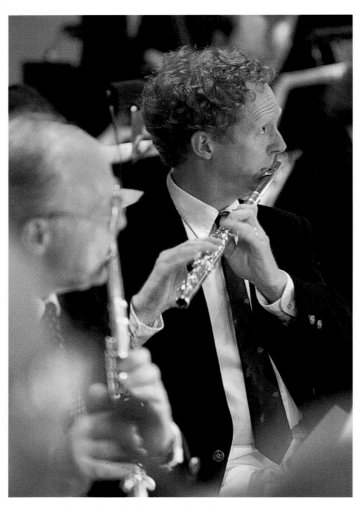

Flutists play in a Chautauqua Symphony Orchestra concert.
The orchestra is composed of approximately eighty members.

Musicians perform in Lenna Hall with its finely balanced acoustics.
Between thirty-five and forty chamber music concerts take place
there each summer.

had to be replaced tended to be seen to with less expense.

Starting in 1970 with the election of Richard Miller, a Milwaukee lawyer and great-grandson of Chautauqua cofounder Lewis Miller, as chairman of the board of trustees, the financial—and ultimately the programmatic—needs of the Institution were addressed. The renaissance of Chautauqua—its fourth period—began.

A younger constituency—some of them the children and grandchildren of longtime Chautauquans, others newly aware of the Institution—inherited or bought and renovated old cottages, while the community expanded as cottages and condominiums were built in late-twentieth-century style in the north and south ends of the Grounds.

Strengthened by a new direction, more money, and a younger constituency, in the 1970s and '80s Chautauqua began to engage the world again and be recognized as a national forum. Its status was symbolized by the exchanges with the Soviet Union from 1985 to 1989. In the 1990s, speakers have included Sandra Day O'Connor, David McCullough, and presidential biographer Michael Beschloss, as well as Bill Clinton, Bob Dole, and Jack Kemp. Platform themes such as "World Competitiveness of U.S. Education and Industry," "The Promise and Threat of Biotechnology," and "American Music: Its Origins and Identity" indicate that Chautauqua is fully engaged in the topics of the day. Some of the issues the Institution wrestles with in its relations to the world outside the fence, however, are whether to try to enlarge the constituency by increasing facilities on the Grounds and setting up programs off-Season in different sites around the country; how to compete with or enter the media explosion in the arts or whether to capitalize on the unique retreat aspect of the Grounds; and how to achieve racial diversity in an Institution whose constituency is almost wholly white.

In the vigorous renaissance of Chautauqua's present lies the strength of its past. The Chautauqua Challenge,

adopted as a statement of purpose by the board of trustees in 1976, says, in part, that Chautauqua is "to be a center for the identification and development of the best in human values . . . to be a resource for the enriched understanding of the opportunities and obligations of community, family, and personal life by fostering the sharing of varied cultural, educational, religious and recreational experience." From John Vincent's statement that "every man has a right to be all that he can be" to the Chautauqua Challenge, we shall look in more detail at how this unique and uniquely American place came to represent culture, continuity, and community on the lakeshore.

But first we need some context.

There were various strains in nineteenth-century American culture that Chautauqua drew on, but there was also a significant shift in how Americans earned their living and where they lived that helped the Institution to succeed. In 1874 the population of the United States was approximately 44 million people. Eighty-five percent of the population lived east of the Mississippi River. The 25 million people north of the Mason-Dixon line and the Ohio River were feeling the loosening of the iron bands of grief that gripped many families who had lost sons, husbands, and brothers in the devastating Civil War, which had ended nine years earlier. But prompting the healing in both North and South was a swelling growth of industry, which between 1860 and 1900 would make the United States one of the great manufacturing nations of the world and turn a largely rural society into a largely urban one. In 1860 only 20 percent of the population lived in cities, but by 1900 that number had almost doubled. This meant that there was a dramatic change in daily life for many Americans. On the farm there had been no fixed hours, although the labor was almost unceasing, and there was limited access to other people, new ideas, and any

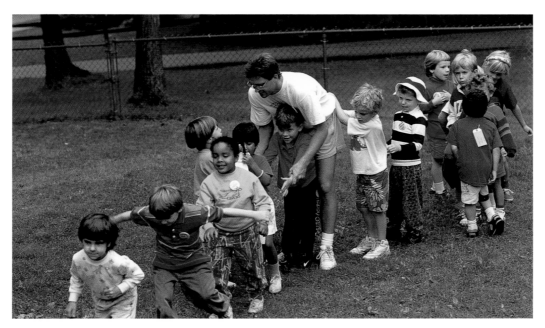

Nursery school pupils line up with their counselor. Older children, aged six to fifteen, may attend Boys' and Girls' Club, day camps on the Grounds.

entertainment. ("They must make their own fun," people used to say, driving past a godforsaken farmstead or crossroads hamlet.) In the city, on the other hand, there were defined hours of work and the stimulation of many new ideas, many new people, and many venues for entertainment, from pool halls to lecture halls.

The new leisure and the new possibilities of filling it, though attractive, were also a little frightening. In the country, you knew who you were—you lived on the Magruder place or the Anderson farm or in the Daubenspeck house—but in the city you were just one of a faceless multitude. Rural American life offered the sense of being an individual within a community. The American tradition of self-sufficiency and the pursuit of happiness promised by the Declaration of Independence were supported, if not handsomely fulfilled, by earning your own living on your own land. But who could feel like an individual in the rush-hour crowd at the corner of Broadway and 23rd Street?

Into this newly found leisure time and the search for a community that would enhance, rather than annihilate, the feeling of being an individual American came—as though tailor-made by God, Congress, and the Founding Fathers—Chautauqua.

A small Chautauquan participates in an Amphitheater church service nestled between benches while her elders rise to sing hymns.

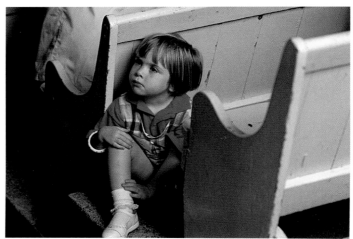

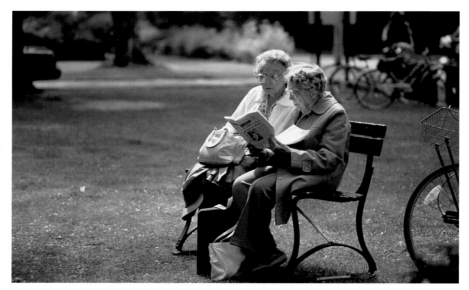

Two longtime Chautauquans read The Chautauquan Daily. *Bicycles are a popular mode of transportation for their younger peers.*

Now a private house, the Grange Hall was built in Greek Revival Style as the gathering place for the farmers' organization, which had great political power during the last two decades of the nineteenth century.

Opposite: Rainy-day umbrellas brighten the rustic bridge over the ravine between the Amphitheater and the Athenaeum Hotel.

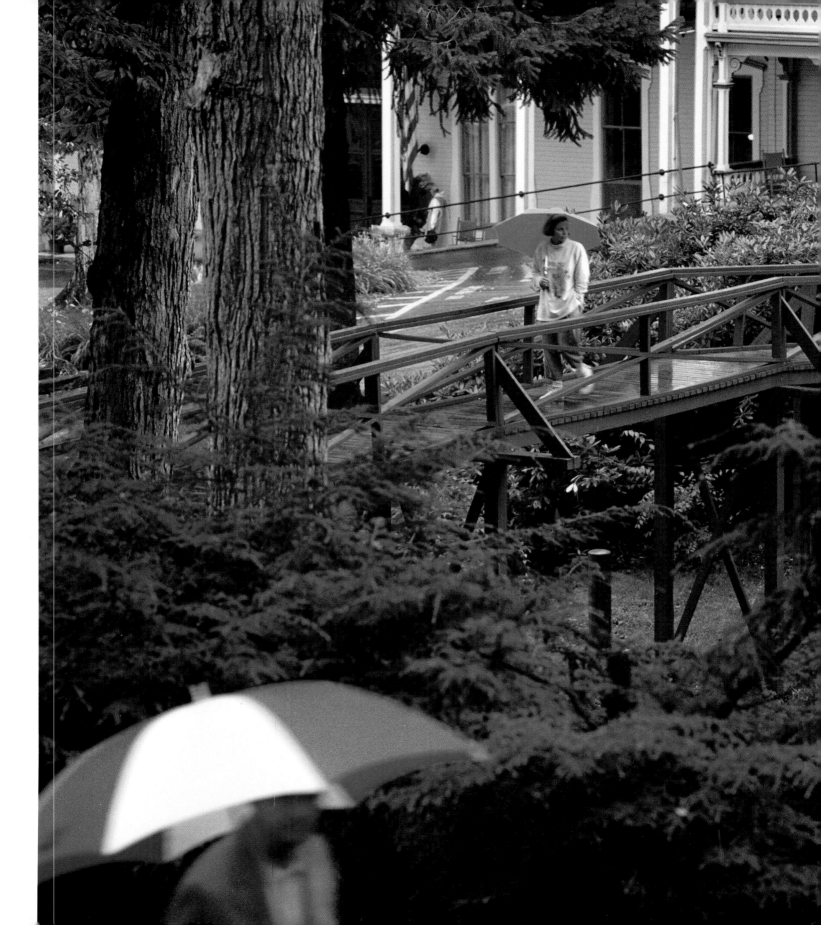

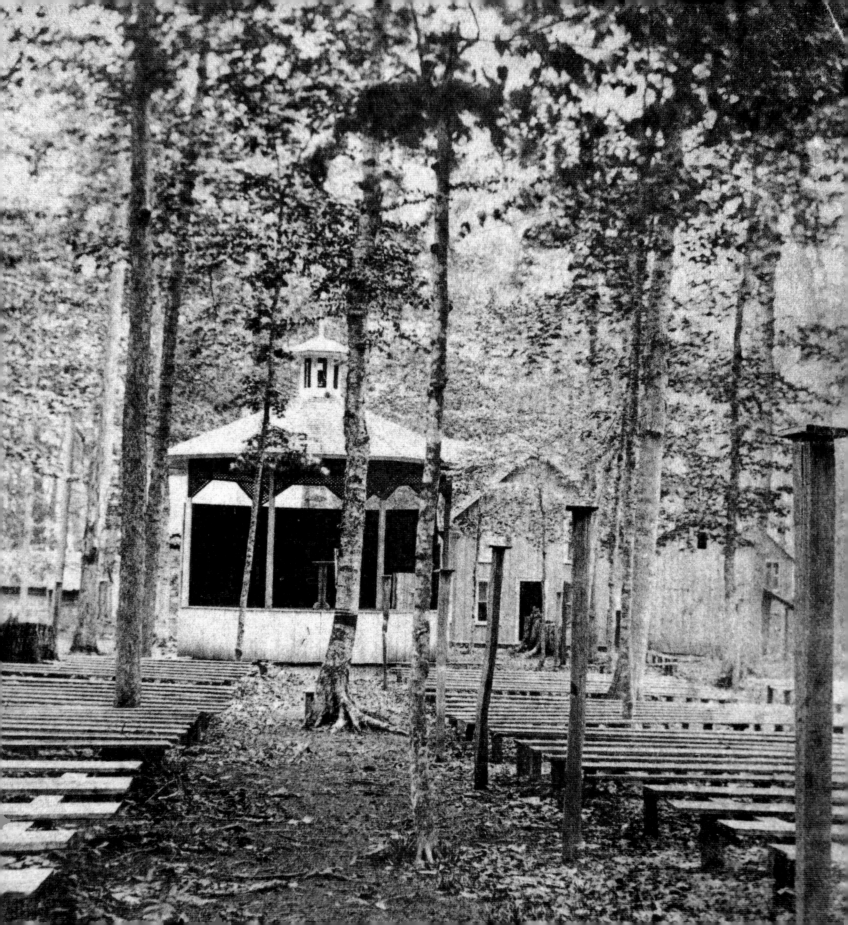

CHAPTER TWO

The First Assembly

In August 1873, Lewis Miller, John Vincent, and their sons, Ira and George, stepped off the gangplank of a passenger steamboat at a point of land sticking out into Chautauqua Lake. They were there to explore the possibilities of creating what would become the Chautauqua Lake Sunday School Assembly—the program of lectures, sermons, and music that evolved into The Chautauqua Institution. On that August evening, however, the Assembly itself was only an idea growing out of Miller and Vincent's mutual interest in the nationally popular Sunday School movement and their respect for each other.

Lewis Miller, born in 1829, was the son of a prosperous Ohio farmer, but he had grown up not liking the drudgery and financial uncertainty of farm life. After trying schoolteaching and plastering, he stumbled into the field where his genius could blossom when he started to work in a machine shop owned by his stepbrother. During the 1850s, the McCormick reaper and other mechanical contrivances began to revolutionize farm labor, ultimately allowing for the large-scale farming that would take over the Great Plains. Miller, fiddling with a reaper patented

The speakers' platform at the Chautauqua Lake Camp Meeting at Fair Point. Lewis Miller and John Heyl Vincent leased the assembly grounds, cottages, and tent platforms for their Sunday School Assembly in August 1874. The poles standing at the ends of the rows of benches held boxes of earth that supported flaring torches for night gatherings.

by Obed Hussey, jointed the arm so that it could follow the contours of the land, something the earlier cumbersome machines had not managed to do. The Buckeye Mower, as Miller called his invention (with a loyal reference to his home state), was immediately successful. It was produced in the thousands in two factories in Akron and Canton by the mid-1860s, and it made him a fortune.

Miller became a leading citizen of Akron, where he indulged in hobbies dear to the Victorians such as landscape architecture, using exotic plantings around his mansion. Beyond his immensely profitable genius for tinkering and his recreational puttering with plants and architecture, however, he had always had the independent American citizen's passion for self-improvement; educational opportunities were of great interest to him. As president of the board of trustees of Mt. Union College in Alliance, Ohio, he encouraged the admitting of women, created a four-term academic year so that students from farming families could take time to work at home on the farm when they needed to, and expanded the scientific curriculum to include soil chemistry and other agricultural sciences. His greatest educational passion, however, was not academics. It was the Sunday School movement.

Throughout the nineteenth century, as the program of study in one-room country schools, small-town "academies," and "ladies' seminaries" became increasingly endorsed by the states and increasingly standardized—

McGuffey's Reader and the *Blue-Backed Speller* were ubiquitous—it had also become increasingly secular. For instance, in Pennsylvania as late as the 1830s there were no state requirements for education because the Pennsylvania Germans had resisted the secular education that would replace their church schools. By the middle of the century, with secular teaching firmly in place in community schools, the major Protestant denominations assumed responsibility for children working in mills who were getting no schooling; they began a Sunday School program to offer a course of general education to them. Before too long, it was seen that this format could also be used to teach religious subjects to church parishioners. Religious instruction was given before or after the morning church service and—something many of us have lost sight of—included classes to serve all ages, adults as well as children.

In connection with Sunday School work, Lewis Miller met John Heyl Vincent in 1868. Vincent, who had been born in 1832, was the son of a merchant; at the age of eighteen he received a license to "exhort" in the Methodist Episcopal Church. Studying as he could at such places as the Newark Wesleyan Institute, Vincent never was able to enjoy a formal college education because of the tremendous need for pastoral ministers on the spot. But he shared with Lewis Miller—and with Americans back to Benjamin Franklin and before—an omnivorous curiosity, a certainty of the universal right to education (not a concept popular in class-ridden Europe), and an enthusiasm for avocational educational programs, which eased the chores and obligations of daily life. Among these were the Lyceum movement, a series of informative lectures that took place in many American cities throughout the first half of the nineteenth century, and Sunday School classes.

When Vincent and Miller met, the minister had achieved a position in his professional career comparable to Miller's success as an industrialist. In 1862 Vincent had

been sent by his church as a delegate to the General Sunday School Convention in London. He became editor of the nationally circulated *Sunday-School Journal*, which he was instrumental in making the vehicle of an interdenominational course of study. Among the parishioners at his church in Galena, Illinois, was Ulysses S. Grant, who would remain a lifelong friend; and in 1865 at General Grant's headquarters he met President Lincoln while serving on the Christian Commission to deal with the effects of the Civil War.

Miller and Vincent talked for several years about organizing a national meeting of Sunday School teachers to emphasize training, teaching methods, and a broad curriculum that would include such subjects as Biblical geography. Vincent suggested that there be a series of meetings set in a number of cities, starting with Akron. Miller, however, promoted the idea of a single meeting that would take place during the summer when public school teachers, who often served as volunteer Sunday School teachers, were free and when recreation could be part of the program.

Among his various activities, Miller happened to be on the board of trustees of a camp meeting at Fair Point on Chautauqua Lake. A uniquely American religious expression, camp meetings tended to take place in rural and wooded areas, and they combined an opportunity for evangelical conversion and the renewal of Christian faith with an opportunity for personal theatrics and emotional release that was otherwise not to be found in the desolate backwoods. The camp meeting phenomenon had electrified the frontier of America with threatening hellfire, conversions aplenty, shouting, preaching, and hymn singing since the evangelical Great Awakening of the 1740s. After the Civil War, the rampaging element of camp meetings was disappearing, but the emotional release for people living straitened lives on bleak farms was still welcome. Both Vincent and Miller were deeply

distrustful both of the methods by which a camp meeting was run and of the emotions it stirred up, which quickly dissipated, leaving few considered or deeply felt beliefs. They also thought the excesses of camp meetings were, in our terms, bad public relations for a Methodist Church that was increasingly middle class.

When Miller proposed that he and Vincent visit the Fair Point campgrounds to consider it for their Sunday School Assembly, therefore, they were enlivened by the idea of turning a camp meeting from a chaotic explosion of hysteria into an educational experience. (Later, after the first Assembly in 1874, Vincent said the program was one of lectures, with very few sermons preached, and no evangelistic services: "The Assembly was totally unlike the camp-meeting. We did our best to make it so.")

Nevertheless, among the mythic American experiences that Chautauqua drew on and combined in making something new was the camp meeting as well as the Lyceum movement. The potent image of the various Utopian communities—the Shakers, the Oneida community, even the first Mormons—scattered across New York State also gave the Chautauqua founders material on which to draw.

The campgrounds at Fair Point were fairly well developed when the Founding Fathers landed on that night in 1873. George Vincent, who was nine years old, ran down the gangplank first and leaped ashore. Later, in a distinguished career as an educator, culminating as president of the University of Minnesota and head of the Rockefeller Foundation, he would claim that his jump from the gangplank made him "the first Chautauquan." The visitors found board-and-batten cottages and tents pitched on wooden platforms around a grove with a roofed platform and enough rows of wooden benches beneath the trees to accommodate two thousand people. There was a "hotel"—an open two-story framework shed with interior canvas walls dividing the "rooms." With

their curious boys in attendance, the stalwart Miller and Vincent wore their citified black tailcoats to dinner with representatives of the camp meeting. Later, as George Vincent would remember, they were "lulled to sleep by the rustling of the corn husks—in the mattresses. All thoughts of the Chautauqua Idea were at that time abandoned. The noble Pilgrim Fathers gave themselves to the abuse of the hotel."

Despite their discomfort, the clergyman and the inventor, each a visionary, saw that the land was good, and they came to an agreement with the camp-meeting leaders to lease the grounds for two weeks the next summer, beginning August 4. Vincent, in his position as editor of *The Sunday-School Journal*, which had a monthly circulation of 100,000, and through the other publications to which he had access, promoted the Assembly tirelessly throughout the winter. DeWitt Talmadge, a flamboyant and controversial clergyman and editor of another religious magazine, wrote: "Soon the Methodists will be shaking out their tents and packing their lunch baskets. . . . Rev. Dr. J. H. Vincent, the silver tongued trumpet of Sabbath Schoolism, is marshalling a meeting for the banks of Chautauqua Lake which will probably be the grandest religious picnic ever held since the five thousand sat down on the grass and had a surplus of provisions to take home to those who were too stupid to go."

On that August day in 1874, spurred on by all the publicity, people from twenty-five states as well as England, Scotland, Ireland, and India poured off the trains in Mayville and Jamestown, at opposite ends of the lake, and piled onto steamers that chuffed up to Fair Point, dumping them and their trunks on the shore. Local people arrived in wagons and buggies until there were nearly four thousand jamming the benches and standing around the edges of the open-air auditorium. The light for that first evening's assembly came from flaring pine torches set in boxes of earth on poles high overhead.

Many years later, Bishop Vincent (he became a bishop in 1888) wrote: "The stars were out and looked down through the trembling leaves upon a goodly well-wrapped company who sat in the grove, filled with wonder and hope. No electric light brought platform and people face to face that night. The old-fashioned pine fires . . . burned with unsteady, flickering flame. . . . The white tents were very beautiful in that evening light."

By the end of the two weeks, between ten thousand and fifteen thousand people had attended the sessions. Many of them were ministers and Sunday School teachers from a variety of Protestant denominations; in his pursuit of ecumenical education, Dr. Vincent had included Presbyterians, Baptists, and Congregationalists on his platform, as well as his own Methodists, and he had been careful to publicize the fact that it would be so. Many were small-town people who jolted to the meeting along dirt roads from their farms and villages. And many more were those literate, intellectually curious Americans who used their new leisure time to read *The Sunday-School Journal*—and anything else they could get their hands on—in their new houses in those proliferating streets in towns and cities all across the country. "There was a hunger of mind abroad in the land."

Life at the Fair Point Sunday School Assembly was not easy, even for nineteenth-century Americans accustomed to chamber pots, hand-pumped water, no central heating, and damp beds. Theologian Jesse Hurlbut, who taught many of the early Chautauqua classes, remembered that "everybody, except such as did their own cooking, ate at the dining hall, which was a long tabernacle of rough, unpainted boards, with a leaky roof, and backless benches where the feeders sat around tables covered with oilcloth. . . . Sometimes it rained, and D.D.'s, LL.D.'s, professors, and plain people held up umbrellas with one hand and tried to cut tough steaks with the other."

Ida Tarbell, the famous muckraking journalist who would crimp John D. Rockefeller's robber-baron style with her "Report on the Standard Oil Company," spent time in her childhood with her family at the first Chautauqua Assemblies; apropos of the closeness of the cottages and tents and the thinness of the partitions in the "hotel," she recalled Mark Twain's remark about a summer hotel where the walls were "so thin you can hear the women changing their minds." "Comfort stations" were located in groves of hemlock trees at every corner for tent dwellers to use. In the 1950s, an old lady who had been a child at the first Assembly told her by-then elderly daughter that, with a combination of New England frugality and rugged individualism, when tent dwellers cooked in those first communal kitchens, they initialed the family potatoes before putting them into the common pot.

After that first evening, which was a devotional service beginning with the reading of Old Testament verses and the singing of "Nearer, My God, to Thee," the program during the next two weeks was determinedly instructional, as Vincent and Miller had set it up to be. Although there were eight sermons at different times, there were twenty-two lectures on the theory and practice of Sunday School work, and seven lectures on such topics as Biblical history and geography. At the end of the two weeks, two hundred people gathered in a large tent and took a written examination of fifty questions on their Bible and other studies. One hundred and fifty-two received diplomas. Such formality would ebb and flow and take different directions at Chautauqua over the years, but one of the most enduring —and appealing—symbols was established at the outset. As an aid to the study of Biblical geography, a favorite subject of Vincent's, a plaster relief model of Palestine was laid down. It included its own little Dead Sea and Jordan River and the various cities of the Bible and used the lakeshore as the Mediterranean. With some modifications to make it more durable, it remains to this day as a monument to the ideals, pedagogy, and sense of fun of the founders.

The first Assembly had been such a success that

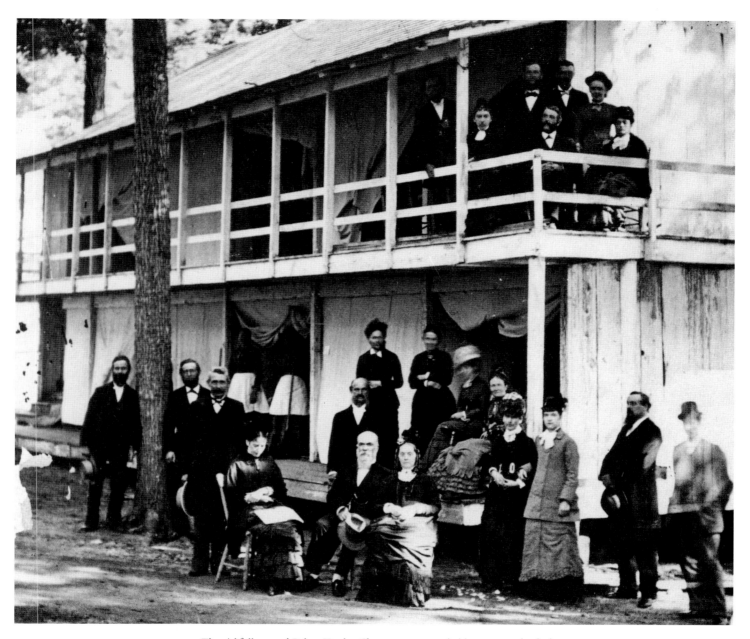

The wishfully named Palace Hotel at Chautauqua was a primitive structure that had
been moved to the Grounds from the Philadelphia Exposition of 1876, where it was first erected.
The rooms divided by canvas recall Mark Twain's male-chauvinist description of a similar summer
hotel where "the walls were so thin you could hear the women changing their minds."
The Palace Hotel's companion structure for speakers was referred to jocosely as "Knowers' Ark."

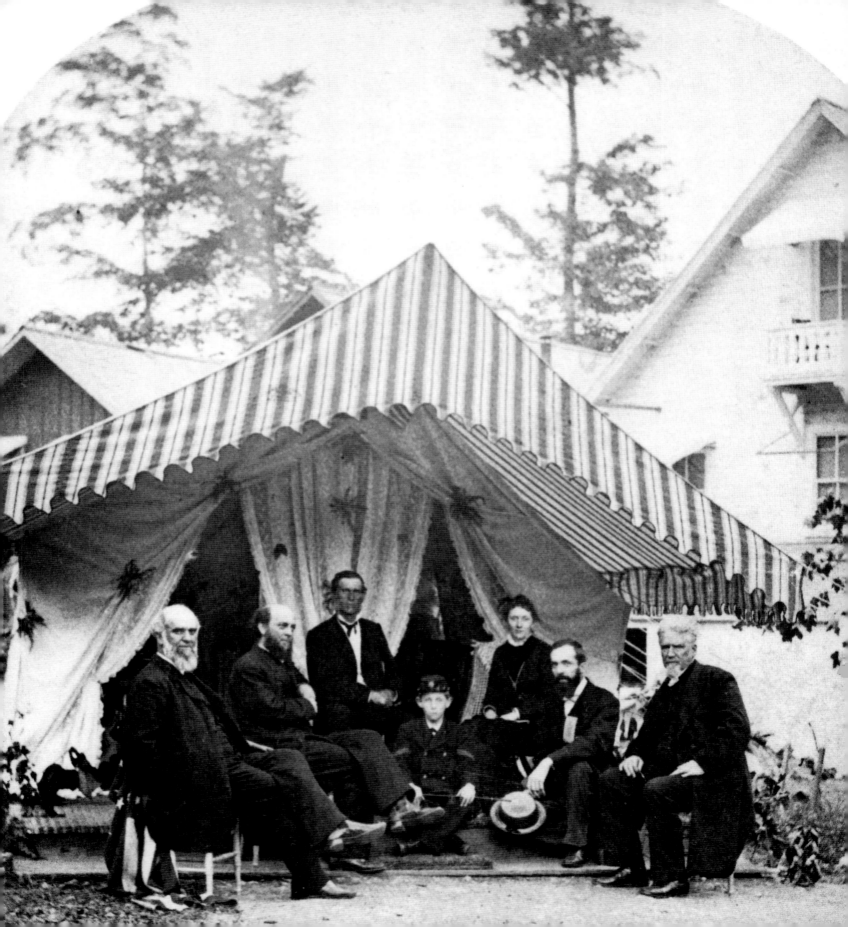

Vincent and Miller decided to do it again. They again publicized the Assembly throughout the winter, and they expanded the curriculum to include map drawing and the study of Hebrew. The resort atmosphere was enhanced with evening concerts on the lake and choral concerts under trees bedecked with Japanese lanterns. Attendance was even better than the year before.

As evidence of his faith in the Assembly's continuing program—and to provide a degree of comfort for himself and his large family—Lewis Miller built a cottage at the back of the open-air auditorium. The increased ease of working with technology, particularly the jigsaw, meant that Victorian furniture makers and home builders drew on a tremendous number of historical and exotic styles, often rather loosely. Gothic furniture sat, pointed crest by curvaceous back, alongside Louis XV Rococo parlor chairs. Similarly, across the land, Gothic cottages stood beside Italianate villas and Swiss chalets. Miller's house was a Swiss chalet done in Stick Style—meaning that the studs and crossbeams were visible on the outside of the house. It was painted white with raspberry trim; part of it had been assembled in one of Miller's Ohio factories. There was a wide porch around the building on which a raspberry-and-white-striped tent was raised during the Season, lest the Millers ever forget the simple shelters used during the origins of their gathering.

Dr. Vincent invited his old friend and parishioner Ulysses S. Grant, now president of the United States, to visit. The president arrived on the steamer *Josie Bell* on Saturday, August 14, 1875. Thirty thousand people crowded the grounds that day and the next and floated on every kind of watercraft; many of the boats were decorated with red, white, and blue bunting. A song was written by

Opposite: Chautauqua founders Lewis Miller (far left) and John Vincent (second from left) relax in the late 1870s with other Chautauquans outside a well-appointed tent.

hymnwriter Mary Lathbury for the president; three addresses were made by various dignitaries throughout his visit; and illuminations were presented in the evening, ranging from the pine torches flaring on their poles to fireworks, which the president enjoyed from the porch of the Miller cottage. With the national attention Grant's visit brought, Chautauqua was launched.

For the Season of 1876, Vincent and Miller faced formidable competition from the huge Centennial Exhibition of the Declaration of Independence taking place in Philadelphia. Undaunted, they expanded the Season to three weeks and declared that Chautauqua would host a Scientific Congress that would be "a centennial exhibition in itself." The program of religious and Bible lectures was, of course, maintained; in fact, many of the scientific lectures were related to matters of faith and religious thought, such as "Alleged Discrepancies between Science and the Bible" and "The Importance of Science to the Religious Thinker." But there was also a full program of lectures and demonstrations dealing with heat, light, electricity, and the makeup of the constellations and the universe. After one lecture Dr. Lyman Abbott, a prominent Congregational minister and publisher, announced, "This lecture makes an evolutionist of me," a remarkable statement in a religiously affiliated program not quite twenty years after the publication of Darwin's *Origin of Species*, especially in light of the fact that the issue is still being debated today.

Another item of modern concern on the 1876 platform agenda was the presence of Frances E. Willard, who would become president of the Women's Christian Temperance Union, an organization that grew out of a Chautauqua meeting during the first season of 1874. Willard was the first woman to speak on the Chautauqua platform on a subject other than Sunday School studies. She had intended to support women's suffrage in her 1876

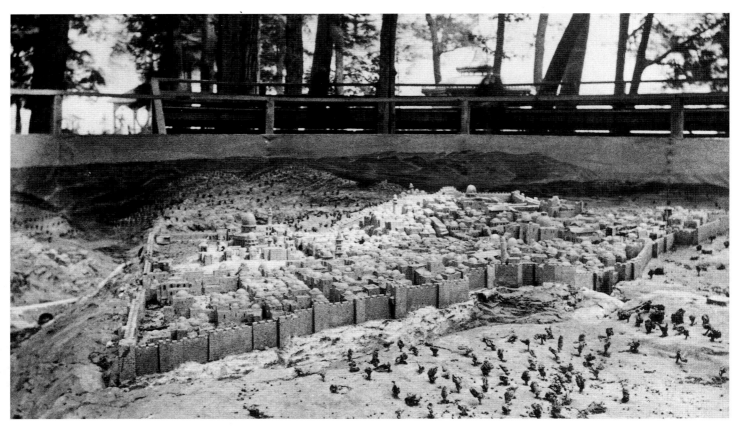

An elaborate model of Jerusalem was placed next to the model of the Holy Land.

speech, but knowing Dr. Vincent's discomfort with the subject, she did not. Her mere presence, however, as a woman speaker and her known sympathies for the suffrage issue laid a foundation for addressing the issues of the day, regardless of how inflammatory or how much at variance with the administration's personal feelings they might be.

Before the 1876 Season opened, the Fair Point Camp Meeting Association, which had leased the Grounds for two years to Vincent and Miller's Sunday School Assembly, was authorized to formally transfer ownership for the sum of $1. Shortly thereafter, as official Chautauqua Institution historian Alfreda Irwin has established, the name of the community was officially changed to Chautauqua. In 1877 a United States post office was opened there, and in 1879 the Season was extended to six weeks. By 1880 the size of the Grounds had almost tripled from the original fifty acres.

It was in 1878, however, that Chautauqua's single most influential educational effort was initiated—one that would give structure over the next fifty years to hundreds of thousands of Americans yearning to learn.

Opposite: John Vincent had a professional interest in developing teaching methods for Sunday Schools. One of his favorite tools was making an outdoor model of the Holy Land. This one at Chautauqua, in which the Holy Land was oriented so that Chautauqua Lake served as the Mediterranean, has been a popular feature since 1874.

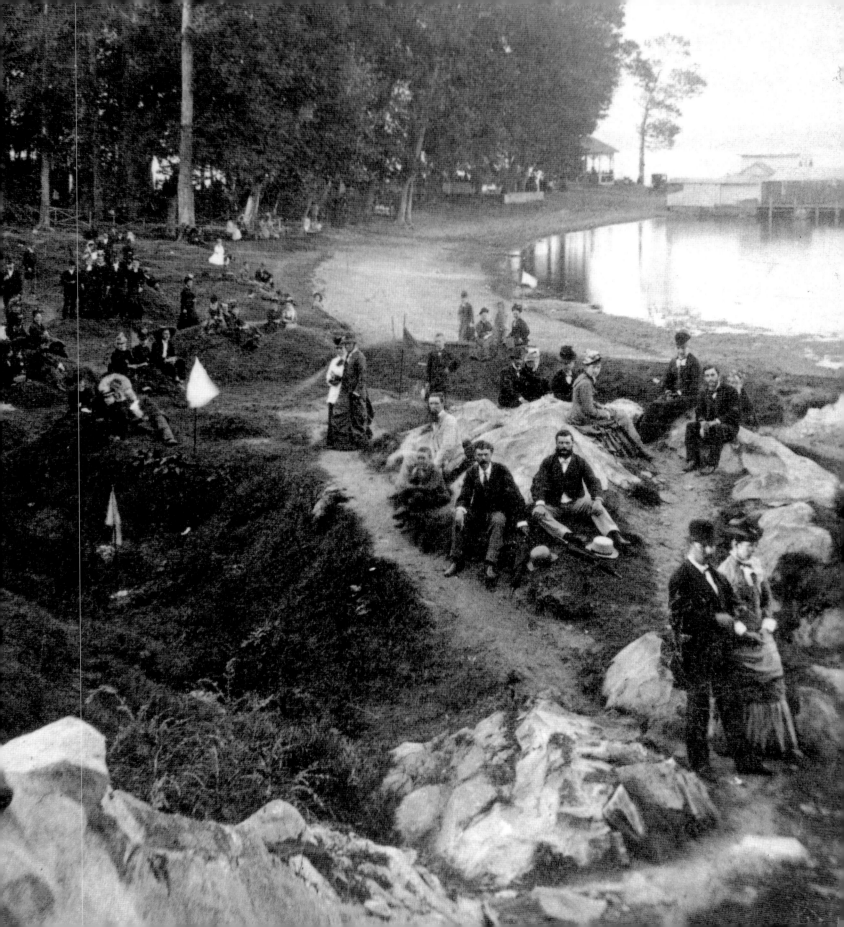

Chautauqua cofounder Lewis Miller on the porch of his "Swiss chalet," part of which had been built in his hometown of Akron, taken apart, and brought to Chautauqua. Tents remained a part of Chautauqua architecture for its first twenty-five years.

Opposite: Lewis Miller's brother Jacob and his wife sit outside their exquisite cottage with its porches decorated in high Stick Style. Every mode of architecture seen in America between the 1870s and the World War II is represented at Chautauqua.

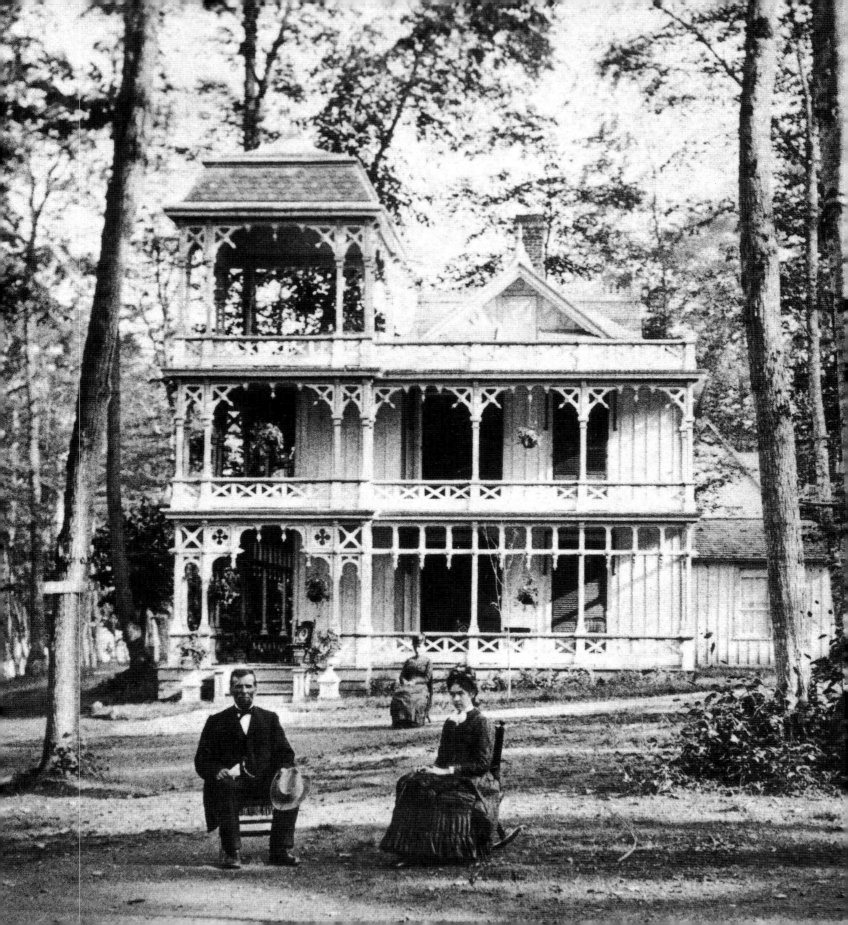

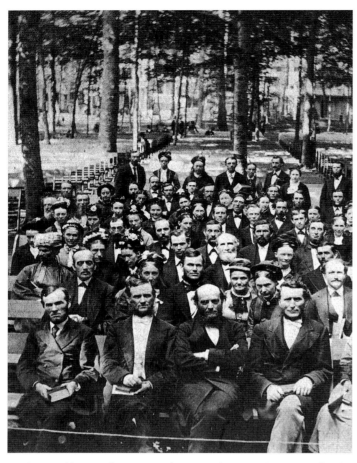

The Assembly Grounds some time after 1876, when ownership was transferred to the Chautauqua Lake Sunday School Assembly, and benches with backs replaced the old ones. President Ulysses S. Grant had visited the 1875 assembly, and Women's Christian Temperance Union president Frances E. Willard spoke in 1876.

Frank Beard, a popular artist of the Civil War, spent a number of summers at Chautauqua in its early days, where he gave sketch-lectures for children and adults.

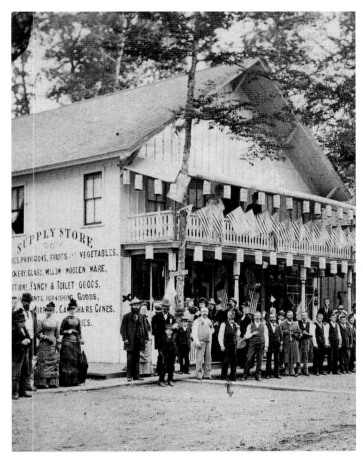

Tent life did not mean roughing it to the Victorians, as the people's clothes and the list of available goods on the wall of the Chautauqua commissary make clear.

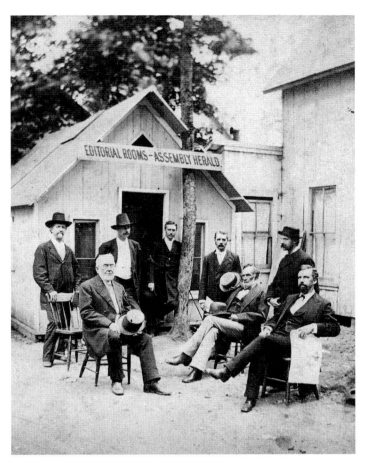

Starting in 1876, Chautauquans have had a daily paper throughout the Season.

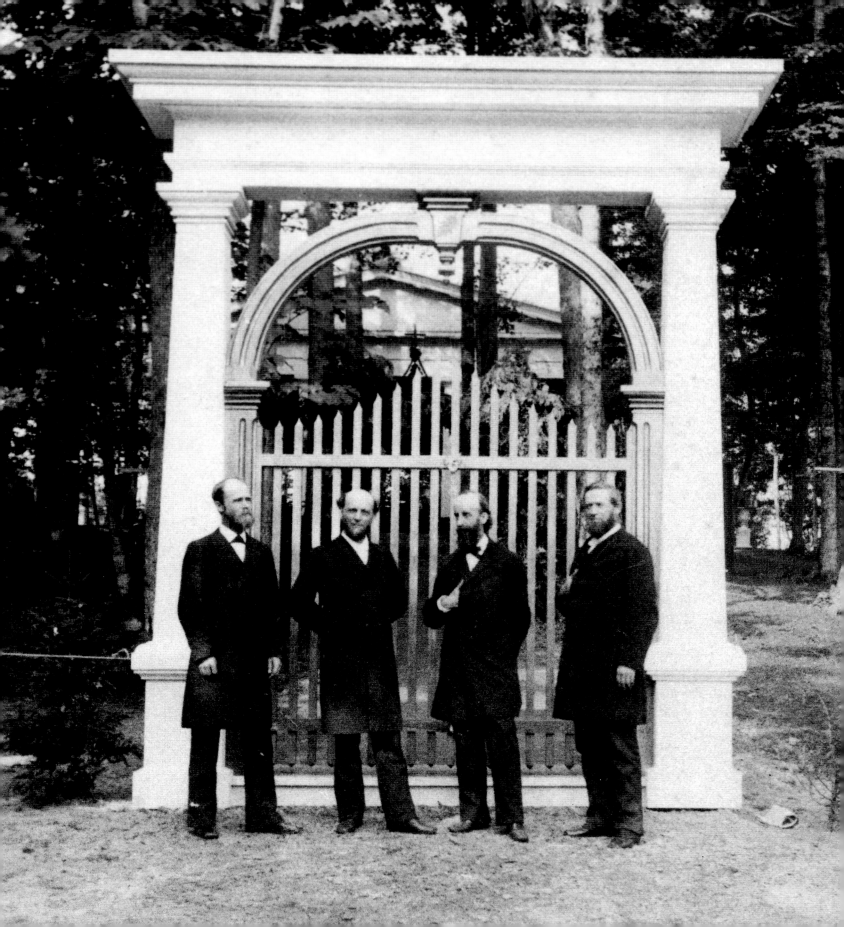

The Chautauqua Literary and Scientific Circle

In 1928 a popular novelist named Zona Gale wrote a sketch of old-fashioned small-town life called "Katytown in the Eighties" for *Harper's* magazine. In it an evening reading circle of townsfolk who are members of the Chautauqua Literary and Scientific Circle meet to discuss their books.

Referring to a work called *The Preparatory Latin Course in English*, one woman says, "Think of 'cordial' being from the Latin word meaning heart. Oh, isn't it wonderful?"

Another one says, "You could take an English page and pick out the different words that came out of Latin!"

Someone asks, "What good'd that do you?"

Several say together, "Why, so to know!"

And then the hostess ingenuously makes one of the greatest justifications of the Chautauqua Movement ever uttered. She says: "It makes you feel as if Katytown isn't all there is to it."

On August 10, 1878, John Vincent announced at Chautauqua the formation of the Chautauqua Literary and Scientific Circle (CLSC). It was to be a four-year course of home reading with a certain number of books to be read each year loosely following academic themes and disciplines. He would later write that the CLSC "aims

Opposite: John Vincent (second from left) and colleagues in front of the Golden Gate at the bottom of St. Paul's Grove, where the Hall of Philosophy sat. Graduates of the four-year CLSC reading program passed through the Golden Gate on Recognition Day.

to promote habits of reading and study in nature, art, science, and in secular and sacred literature . . . especially among those whose educational advantages have been limited."

At another time he explained more specifically that the CLSC was for "busy people who left school years ago . . . for people who never entered high school or college, for merchants, mechanics, apprentices, mothers, busy house-keepers, farmer-boys, shop-girls, and for people of leisure and wealth who do not know what to do with their time." In other words, it was for all of America in those pre-radio, pre-television days when mechanical devices were beginning to enable the workers of the world to lift their eyes from the plow and the washboard.

Before Vincent made his announcement on that August Saturday in the old open-air pavilion that predated the Amphitheater, he had cautiously enlisted the support of several prestigious Chautauquans, including the president of nearby Allegheny College. As he explained what the course entailed, Dr. Vincent, with unaccustomed modesty of vision, said he would be satisfied if ten people volunteered for a start. In fact over seven hundred people signed up in the next three days, and ultimately eight thousand registered for the first class, which called itself the Pioneers. By 1891 Vincent said that 180,000 people had enrolled, although only about 12 percent had completed the four-year course. Still, eight hundred showed up at Chautauqua in 1882 for the graduation ceremony for

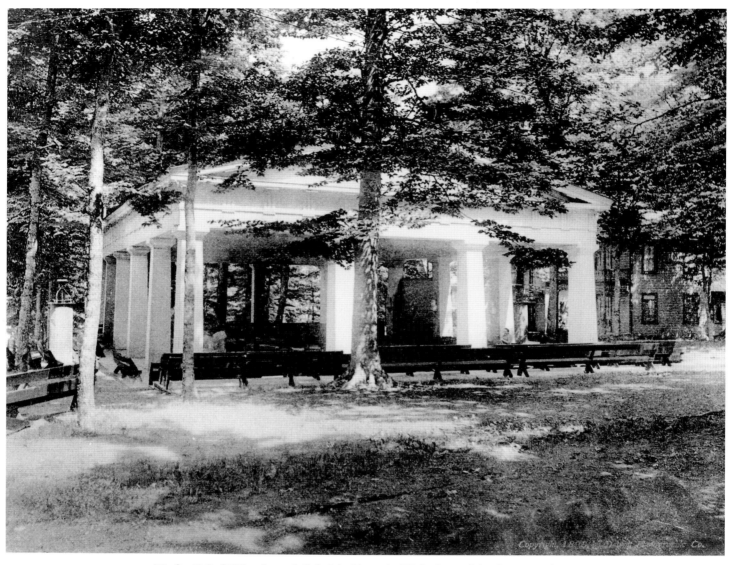

The first Hall of Philosophy was built by John Vincent in 1879 for the use of the Chautauqua Literary
and Scientific Circle, the first adult reading club in America. The lofty aspirations
of the group were symbolized by the busts of Plato, Socrates, Goethe,
and Shakespeare that decorated the pillars.

that first class; and by the 1920s, more than 300,000 had enrolled.

The range of subjects covered is an indication of the CLSC's fearless and sophisticated exploration of almost any topic. The first book that Vincent selected was *A Short History of the English People* by John Richard Greene; others were *English Literature* by Stopford Brooke, *Recreations in Astronomy, with Directions for Practical Experiments and Telescopic Work* by Henry White Warren, and *Fourteen Weeks in Human Physiology* by J. Dorman Steele. Although the first class's reading included a book called *The Word of God Opened*, specifically theological books were not included in the curriculum after 1894 because of the diverse interests of the readers nationwide.

The correspondence in the CLSC archives at Chautauqua shows an appreciation for what it accomplished from both high and low. Andrew Carnegie wrote: "I have found this in visiting the homes of our working men, that, wherever I saw a row or two of books upon his shelf and a harmonium in his parlor, we had here one of our most valuable men." The letters written by the CLSC readers themselves, however, from locations remote both geographically and socially make one feel—achingly— the depth of its effect. Ten thousand circles were established in the first twenty years, a quarter of them in villages with a population of less than five hundred. In his centennial history, *Chautauqua*, historian Theodore Morrison mentions a Mississippi riverboat captain who read on the bridge of his ship and an army officer's wife who was so isolated on the prairie that she cried for pleasure when her books arrived. There were a number of circles in prisons from New York to Nebraska; and Bishop Vincent sent a message in 1890 to the fifty-seven readers in the Look Forward Circle, addressing them as "My fellow students in the Nebraska Penitentiary." One woman wrote to explain why she was behind: "I live on a farm,

and my husband has no help except what I give him. All of the time I am not doing housework, I am obliged to drive the horse at the horsepower. . . . I have done my reading while driving the horse for the last two months, but I cannot write while driving."

Katytown certainly wasn't all there was to it.

Starting in 1882 with the graduation of the Pioneer class, there has been a ceremony known as Recognition Day every year for any graduates who are able to come to Chautauqua and care to participate. As they still do, the graduates marched through the Grounds behind a banner that their class had designed, to a Golden Gate, literally a pair of gilded wooden gates, at the foot of a grove where the white-pillared Hall of Philosophy had been erected in 1879. Small children in white—as many as sixty around the turn of the century—led the way with baskets of flowers, dignitaries spoke, and the graduates received diplomas with arcane distinctions indicating how many books each had read. Fourteen books beyond the assigned four per year earned the graduate membership in The Guild of the Seven Seals. The paraphernalia and the distinctions suggest Vincent's superb marketing sense in an age when fraternal lodges with their secret grips, plumed hats, banners, and sometimes philanthropic agenda were wildly popular. The lodges—and the CLSC—gave people a sense of belonging as society restructured itself following the Civil War. When James A. Garfield visited Chautauqua in the summer of 1880, while campaigning for the presidency, he said, "It has been the struggle of the world to get more leisure, but it has been left to Chautauqua to show what to do with it."

But even beyond providing structure and instruction in an uncertain time, the CLSC's purpose, as described by Vincent in positively religious language, is for people who "hope and resolve to go on and on and up and up and 'higher yet' until they shall be accounted among those 'who are worthy to be crowned.'" Recognition Day was

"when the 'Golden Gate' shall be opened and children with their baskets of flowers, conforming to customs from time immemorial, will strew with blossoms the pathway of pilgrims under the 'arches of the Hall on the Hill.'"

Vincent's language suggests that study was a way to salvation, and graduating was heaven. This was probably not an exaggerated metaphor for the whole new world that CLSC books offered the woman who had to help her husband "at the horsepower."

Two other programs grew out of Chautauqua in its first fifty years. The independent Chautauqua Assemblies that emerged across the country, which had no formal relationship with the parent Chautauqua, were usually settled summer communities with an open-air pavilion or "tabernacle," dining halls, and cottages. The parent Chautauqua would often help by suggesting staff and speakers and planning programs.

By 1904 there were nearly three hundred Chautauqua Assemblies. Some had ambitious programs, booking prominent speakers and luring large crowds to hear them. But in the face of the movies, the automobile, and the radio, and without the substantial financial resources and the intense loyalty of the constituency of the original Chautauqua, most of the independent programs had fallen by the wayside by 1930. At least twenty-five, however, survive and are now part of the Chautauqua Network, an informal organization guided by historian Alfreda Irwin since its founding in 1983. Today, there are even some new Chautauquas, including one called the Tri-Cities Chautauqua in Michigan, a program of lectures and entertainment for all ages developed by a local teacher.

The name also lives on across the country in places as different as Norman, Oklahoma, and Pacific Palisades, California, where there are streets named Chautauqua. These streets may be named for an assembly that was located there, or they may be named for the campground where a traveling tent show known as the Chautauqua Circuit was located for a summer week or so. The traveling Chautauquas were created in 1907 by a man named Keith Vawter, a partner in the Redpath talent bureau. He worked out a contract system whereby certain inhabitants of the towns hosting the Chautauqua Circuits were legally responsible for the fees. Vawter also devised an elaborate system of traveling and shipping trunks and performers so that the singers or speakers moved to a different Chautauqua encampment each night. Gay MacLaren, a Chautauqua Circuit musician, leaves a crisp inventory of the program in her memoir, *Morally We Roll Along*: "A Chautauqua programme was made up of about two-thirds music and dramatics and one-third lectures. . . . [It] was served by the greatest aggregation of public performers the world has ever known. There were teachers, preachers, scientists, explorers, travelers, statesmen, and politicians; singers, pianists, violinists, banjoists, xylophonists, harpists, accordionists, and bell-ringers; orchestras, bands, glee clubs, concert companies, quartettes, sextettes, and quintettes; elocutionists, readers, monologuists, jugglers, magicians, yodelers, and whistlers. . . . Music was provided Chautauqua patrons in every conceivable form from banjo trios to forty-piece bands, from ladies' quartettes to Madame Schumann-Heink and Alice Nielsen."

The contract system and the traveling arrangements made the system profitable. In its peak years, there were more than one hundred traveling shows and upward of 10 million tickets sold in a single summer. The Chautauqua Circuit flourished between 1910 and the late 1920s, until it too gave in to the technologically sophisticated entertainment of the flapper age.

It is worth noting, however, that without the "hunger" for information and entertainment "abroad in the land" and the model of the original Chautauqua, no mechanics of payment and travel in the world would have made the circuits the successes they were.

The CLSC class of 1918 at the foot of the steps of the Hall of Philosophy.
Flower girls were a feature of many Chautauqua pageants.

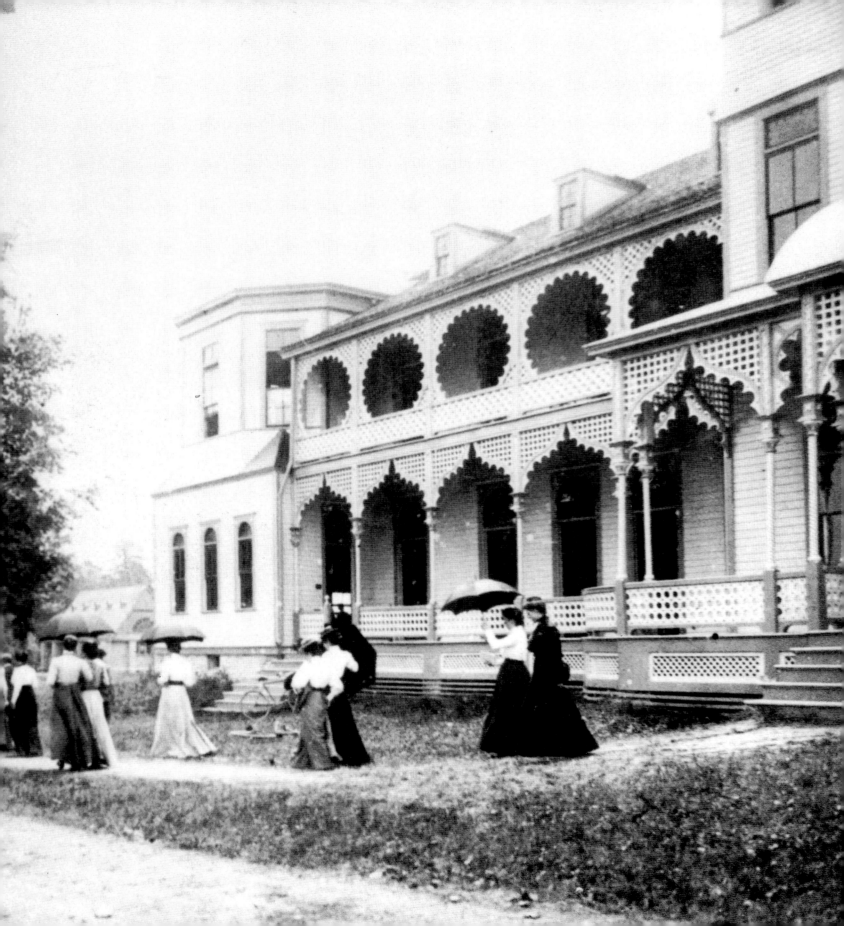

CHAPTER FOUR

A City Beautiful

The remarkable breadth of Chautauqua's program as it exists today is possible because of the ideal of accessible adult education from which the founders never wavered, coupled with a flexibility about what that ideal might be. As early as the sixth Season, 1879, Latin, German, French, Anglo-Saxon, and Asian languages were added to the program under the title of School of Languages. This was the beginning of the formal summer-school curriculum at Chautauqua. The same year, a Teachers' Retreat was held on the Grounds for public-school teachers, and the next year the two programs were joined. A system of correspondence courses was introduced in 1881; it was a development of the possibilities Dr. Vincent had seen in the CLSC. Instruction in music theory began on the Grounds at this time as well.

In 1883 a precocious young scholar named William Rainey Harper came to Chautauqua as a Hebrew instructor. Harper would be in attendance during the summer, while remaining on the faculty of the Baptist School of Theology in Morgan Park, Illinois. Harper's affiliation

Opposite: The Moorish Barn was built for classrooms for the Chautauqua university program in 1887 and torn down in 1916. Students leave class on a rainy day around 1900.

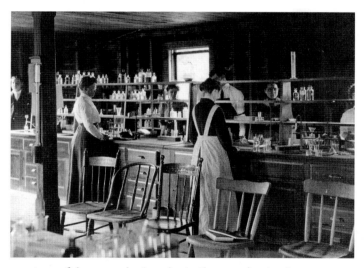

A turn-of-the-century chemistry class in Chautauqua's university program.

with the Baptists particularly appealed to Vincent because they had established a camp with a hotel and lecture hall across Chautauqua Lake at a place they were calling Point Chautauqua, and Vincent expressed to his son, George, his concern that soon they would find "some bright, aggressive young minister of their denomination, put him in charge over there, and give him a free hand." Although Point Chautauqua never developed in any organized way, Vincent was determined to forestall the Baptists by hiring

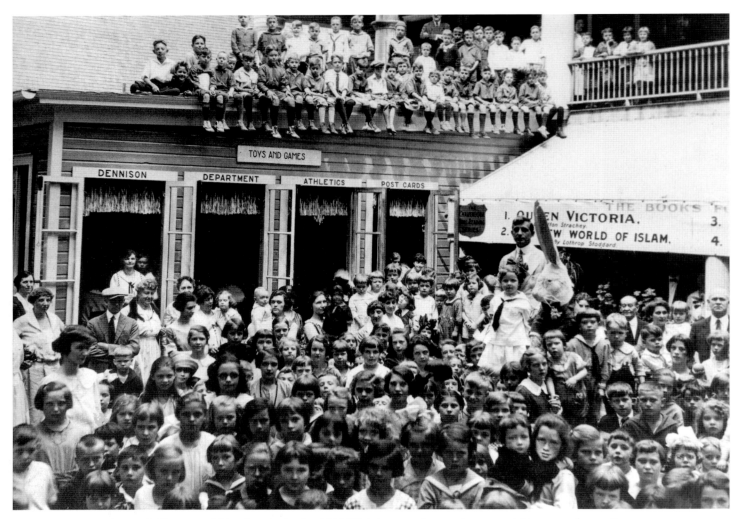

A group of Chautauqua children from the Boys' and Girls' Club day camps (apparently accompanied by an out-of-season Easter Bunny) crowd the CLSC headquarters in the early 1920s. Lytton Strachey's controversial biography of Queen Victoria was published in 1921. Its designation as a CLSC book illustrates Chautauqua's spirit of fearless inquiry.

his own "bright aggressive young minister." Harper, who had graduated from Muskingum College in Ohio at the age of thirteen and gotten a Ph.D. from Yale at the age of nineteen, was a twenty-seven-year-old dynamo when he came to Chautauqua.

That same year, Chautauqua received a charter as a university with degree-granting powers. Harper became responsible for administering the entire educational effort at Chautauqua and even helped to plan the lecture plat-

form. In 1886 he went to Yale as a professor of Semitic languages, while continuing to direct Chautauqua's formal educational program, as principal of the College of Liberal Arts. Harper's academic status drew excellent professors from the elite eastern universities to Chautauqua, and they were impressed by the students' zeal and accomplishments.

Chautauqua, with its tremendous appeal—which was realized in the CLSC, *The Chautauquan Magazine* (the

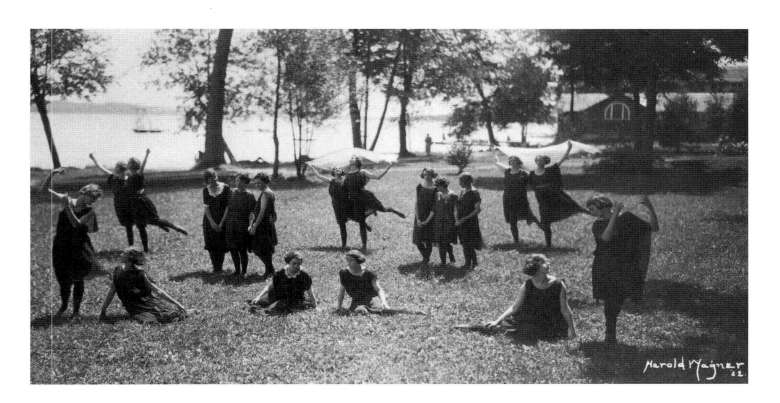

Dance has been practiced and taught at Chautauqua since soon after the turn of the century, although Bishop Vincent disapproved of ballroom dancing. These early dance classes, in the mode of Loie Fuller and Isadora Duncan, were held near the lakeshore.

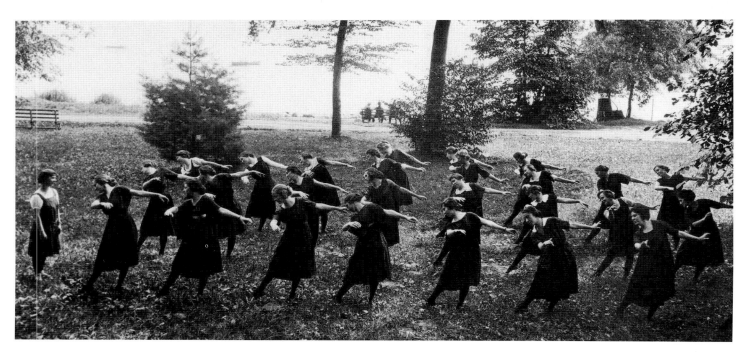

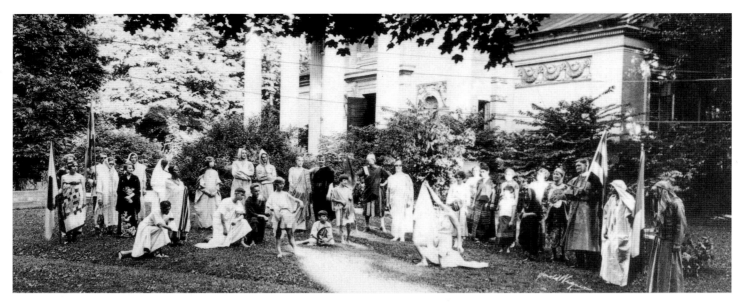

Pageants, such as this one outside the Hall of Christ in 1928, were particularly popular when they dealt with religious subjects.

organ of the CLSC), and the influence of the name itself—was not, however, meant to be a degree-granting institution. Bishop Vincent, probably with a lifelong regret for his own lack of a college education, had thought that a formalized course of study was necessary for the credibility of the Chautauqua name and to redeem it from the charge of superficiality leveled at the Assembly platform program. But the Bishop's "people who had never entered high school or college, [his] merchants, mechanics, apprentices, mothers, busy housekeepers, farmer-boys, [and] shop-girls," because of their very business had no time for formal education; and people with the money and at the age for college needed more than summer courses. That courses given during the Chautauqua Season could grant college credit that could be applied elsewhere was an appealing part of the summer program and has remained so in the areas of art, theater, and music to this day. As a formal university, however, Chautauqua was miscast. It was a tribute to its leadership

that they experimented with the form, and then, at the right time, after ten years, gave it up. By 1892 the title "university" was dropped, and the formal educational program was reorganized, still under the leadership of Harper, who had gone in 1891 to become the first president of the University of Chicago, funded by John D. Rockefeller.

Between 1893 and 1898, Harper attempted to radically change the structure of Chautauqua, gutting it of its most valuable asset, the CLSC. Chautauqua had felt the effects of the nationwide financial downturn that occurred in 1893. The present Amphitheater had been proposed when the Institution had a cash surplus, but building it that year was a tremendous expense. The Season ticket price of $5 per person was not keeping up with expenses, particularly the cost of running the formally structured university programs; and private philanthropy, particularly Lewis Miller's, was lagging behind that of other years. Harper proposed reorganizing the Assembly so that it would be less expensive to run and popularizing the platform so that

the constituency would be broadened. He also suggested raising the gate fee—a cry that would echo down the years.

Then he proposed that the CLSC, *The Chautauquan Magazine*, and the books published for the CLSC under the rubric of The Chautauqua Press—all of which were profitable—be moved to Chicago under the management of a new nonprofit organization to be called The Chautauqua Institute. Initially Harper had the support of Bishop Vincent, whom he shrewdly said should continue as Chancellor of *both* the Chautauqua Assembly in New York State and the new Chautauqua Institute, and he obtained a promise of $25,000 from a Miss Helen Miller Gould of Irvington-on-Hudson, New York, with the stipulation that a permanent endowment of $100,000 be raised before January 1, 1899.

When this was taken to the board of trustees of the Chautauqua Assembly in the summer of 1898, Harper's plan was seen as the evisceration of the Assembly that it in fact would be. Harper continued to maintain that the CLSC was being "bled for the sake of Chautauqua and Chautauqua has lain down on the CLSC . . . and failed to do many things which otherwise she would have done." Bishop Vincent's son, George, had followed Harper to the University of Chicago where he had taken his Ph.D. in sociology. His long relationship with Harper was close. It was through George, therefore, that Harper issued the tacit threat of starting a rival organization to the CLSC in Chicago, if his plan was not followed. By the fall of 1898, the Bishop had come to his senses, and he paid a visit to Miss Gould, who transferred her $25,000 to the Chautauqua Assembly, on the condition that an additional $25,000 could be raised.

Without the Bishop's support and in the face of the trustees' opposition, Harper could only withdraw his plan. He resigned his position as head of the Chautauqua school program on May 31, 1899. By August he had put into motion a plan of organized reading groups to function under the Extension Department of the University of Chicago. Harper never acknowledged his debt to Chautauqua in the programs he initiated in Chicago.

The reason, of course, that Harper wanted to "reorganize" the CLSC under his own leadership in his own city, rather than just imitating it at the start, was the incredible potency of the Chautauqua name. In the last decade of the nineteenth century, everybody knew about

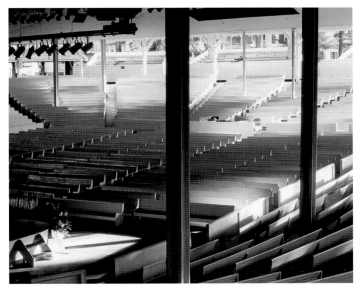

The Amphitheater, built in 1893 at a cost of $24,000, seats five thousand people. The concave curve of its wooden ceiling makes for particularly fine acoustics, important in the oratorical days before electrical amplification.

Chautauqua, and practically everybody came to it. Jacob Riis, the crusading journalist who declared his own war on poverty and wrote *How The Other Half Lives*, had a piece in *The New York Herald* on August 15, 1897, called "The Real Chautauqua." In the midst of fulsome praise for Bishop Vincent, whom he calls a poet ("none but a poet could have conceived Chautauqua"), and Chautauqua itself, he says, "The thing that strikes the

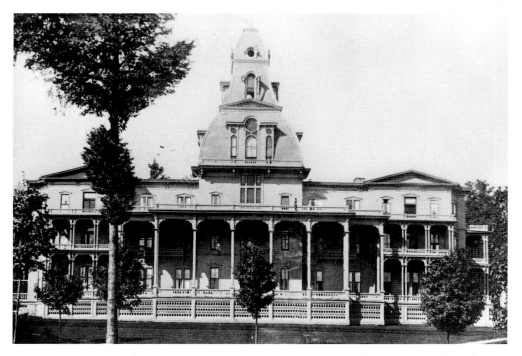

The Athenaeum Hotel, built in 1881 in grand Second Empire Style, provided fit accommodations for platform speakers and dignitaries, as well as prosperous vacationers. The top two floors of the tower were removed in a 1923 renovation.

Athenaeum Hotel waiters, c. 1885. Chautauqua has always been staffed largely by college students. In 1907 Alexander Woollcott, who would become a member of the famed Algonquin Round Table in the 1920s, wrote home: "You needn't sniff at my occupation for the summer. Almost all the waiters at Chautauqua are college men. . . . It's a great place with six or eight entertainments every day all free."

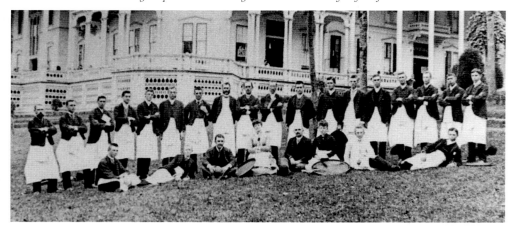

Opposite: The Assembly Herald, the precursor of The Chautauquan Daily, was run as a profit-making operation by the Rev. Theodore Flood. By the 1880s, it had moved out of its tent office. A reporter in the early days was Ida Tarbell, later known for her muckraking journalism for McClure's Magazine, where she savaged John D. Rockefeller's practices in building Standard Oil.

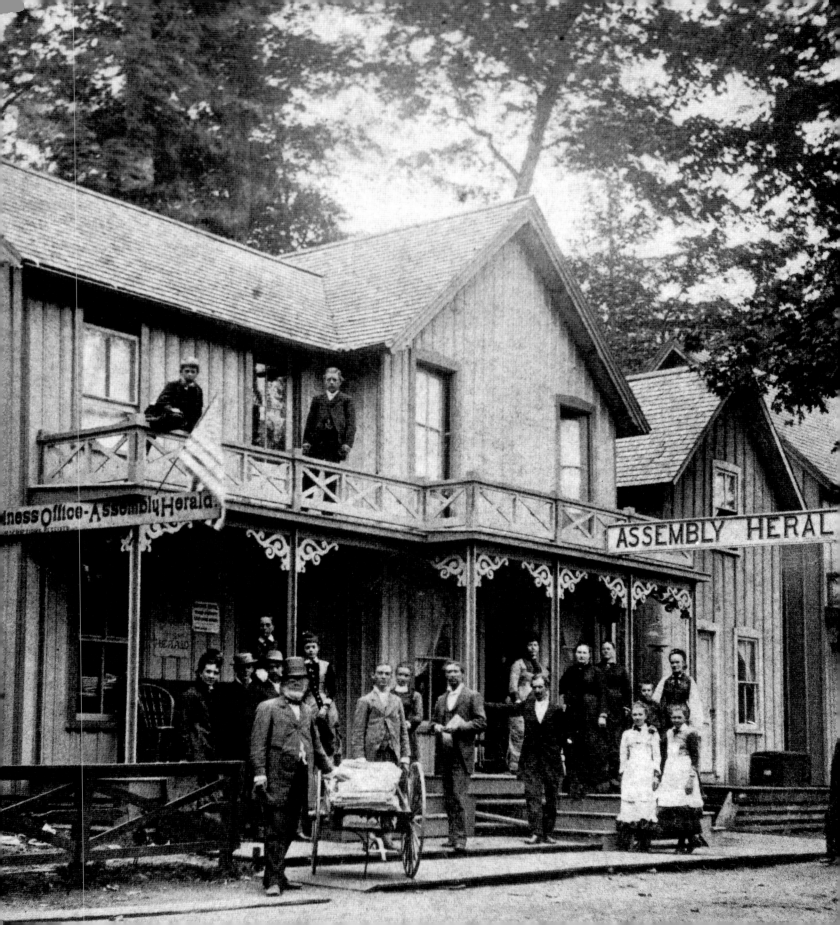

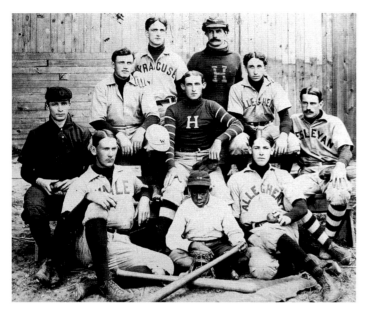

In the early 1890s, members of the Chautauqua baseball team sport their college affiliations. Alonzo Stagg, "The Grand Old Man of Football," who coached at the University of Chicago from 1892 to 1932, is the seated figure at the left. He taught athletics at the Institution.

stranger with wonder at first sight is the number of gray haired men and women who elbow the young at their studies; later on, when at the boat race on the lake he sees them perched together on Mount Hermon and on the slopes of Mount Lebanon in the miniature Holy Land on the shores of the lake, applauding wildly their favorites, the wonder ceases. He perceives that eternal youth is the badge and symbol of Chautauqua. Ideas do not grow old, and enthusiasm knows no decay or death."

There were dissident voices, however, and one of the clearest belonged to William James, the psychologist and brother of novelist Henry James. William James came to lecture in 1896 and wrote about his week at Chautauqua in terms that say as much about the writer as his subject.

I went in curiosity for a day. I stayed for a week, held spell-bound by the charm and ease of everything, by the middle-class paradise, without a sin, without a victim, without a blot, without a tear.

And yet what was my own astonishment, on emerging into the dark and wicked world again, to catch myself quite unexpectedly and involuntarily saying: "Ouf! what a relief!" Now for something primordial and savage, even though it be as bad as an Armenian massacre, to set the balance straight again. This order is too tame, this culture too second-rate, this goodness too uninspiring. This human drama without a villain or a pang; this community so refined that ice-cream soda-water is the utmost offering it can make to the brute animal in man; this city simmering in the tepid lakeside sun; this atrocious harmlessness of all things, I cannot abide with them . . . in this unspeakable Chautauqua there was no potentiality of death in sight anywhere, and no point of the compass visible from which danger might possibly appear. . . .

Bourgeoisie and mediocrity, church sociables and teachers' conventions, are taking the place of the old heights and depths and romantic chiaroscuro. And, to get human life in its wild intensity we must in future turn more and more away from the actual, and forget it, if we can, in the romancer's or the poet's pages. The whole world, delightful and sinful as it may appear to one just escaped from the Chautauqua enclosure, is nevertheless obeying more and more just those ideals that are sure to make of it in the end a mere Chautauqua Assembly on an enormous scale. . . . Even now, in our own country, correctness, fairness, and compromise for every small advantage are crowding out all other qualities. The higher heroisms and the old rare flavors are passing out of life.

From the distance of the most brutal century in the history of the human race, when Armenian massacres were but the precursors of wars fought on terms unimaginable to James, "correctness, fairness, and compromise" seem qualities devoutly to be wished, and James's longing for "human life in its wild intensity" seems criminally sentimental.

A Chautauquan who appreciated the great names, including James's, who came to the Assembly in the early years was Inez Harris Robinson. Born in 1873, Robinson first came to Chautauqua with her parents in 1879 and

then returned throughout the rest of her long life whenever she was not living abroad with her husband, a secretary for the YMCA. Writing about her youth at Chautauqua, Robinson says, "Of the long, long list of distinguished men and women whom I saw and heard at Chautauqua were Presidents Garfield, McKinley, Theodore Roosevelt, and Taft, Dr. F. W. Gunsaulus in his great lecture on Savonarola, Rev. R. H. Conwell on 'Acres of Diamonds,' Bishop Fowler in his masterpiece on Lincoln, Booker T. Washington—'Up From Slavery,' Edward Everett Hale, Kate Douglas Wiggin, Professor C. T. Winchester in his English Cathedral series, Susan B. Anthony, Julia Ward Howe, Jacob Riis, Frances E. Willard, Jane Addams,—All these I distinctly remember besides a host of others."

Some of the names and subjects have a quaint period air—probably no one can easily identify Dr. Gunsaulus's "great lecture on Savonarola" today—but others are vibrant enough, including Kate Douglas Wiggin, who wrote *Mrs. Wiggs of the Cabbage Patch*. And others— Booker T. Washington, Susan B. Anthony, even Julia Ward Howe, author of "The Battle Hymn of the Republic," are simply mythic in the American memory.

It is well worth noting, in terms of the Chautauqua leaders' determination to consider all aspects of social, intellectual, and spiritual life, that in 1893, the first summer of the present Amphitheater, one of the speakers was Rabbi Henry Berkowitz of Philadelphia, who would go on to found the Jewish Chautauqua Society, an organization that promoted Chautauqua's programmatic structure in Jewish community groups. Rabbi Berkowitz said to the assembled crowd on that fateful night:

Let me but ask you that what has been claimed on this platform tonight shall prove itself true: that Chautauquans are open minded and open hearted and will give us a welcome. Let us be of you in this educational movement. Let us have enough tolerance and generosity with one another that though we may disagree in obeying the dictates of our conscience in some matters of dogmatic and doctrinal religious questions, let us join hands for education in the true American spirit to make religion, as has been well said before, more intelligent and make recreation more respectful and more reverent.

Inez Robinson left a nicely detailed picture of tent life for typical summer Chautauquans in those days, as they rushed from classes to lectures, from choral groups to canoeing. Robinson's family had owned cottages that were part board-and-batten and part tent since 1882, but in 1892 her mother built a new house in the south-central part of the Grounds.

[It was] a house of two rooms and an attic . . . with a very large tent floor in front. Some mistake was made when the blue and white tent shipped, for the "fly" [the covering of the tent] was so large that it came clear to the floor on the sides making the tent look as if it were a little old woman in a hood.

We divided the tent by curtains into a living room and a

A class of little girls, c. 1895, being read to while they learn to make "Dolly's Clothes," as the sign on the right promises.

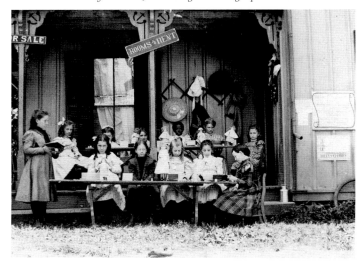

bedroom containing two double beds. Another double bed was in the cottage, in Mother's room, and two more in the attic which could only be reached by a very long step-ladder. The attic had a window in each gable so was light and airy. . . . We thoroughly enjoyed our tent life. . . . One day it rained as "it sometimes does" at Chautauqua. Our crowd had spent the afternoon reading aloud for the rain fell in torrents. It grew late, finally the boys who were waiting on table at the Hotel turned up their collars and ran but the rest stayed. Mother grew nervous. Usually some one went to the bakery in the afternoon and bought baked beans, rolls, cake etc. for supper, and this day there wasn't a thing available in the house. Finally she dressed Frank in his bathing suit, gave him a covered pail and sent him after milk. Then she made pan-cakes and called us to supper. "The best meal I ever ate," one of the boys said (Lebbus Harding Rogers of New York City).

There are several interesting things about this passage worth noting, in addition to its good humor and charm. The fact that in 1892, eighteen years into the life of the Assembly, speakers such as President Garfield, Frances E. Willard, Susan B. Anthony, and Jacob Riis were appearing in the Pavilion, and the fact that at this time people were still building tent houses suggests how high-minded and close to its roots the Assembly remained. There is also the mention of "the boys who were waiting on table at the Hotel" indicating Chautauqua's continuing custom of staffing its summer services with college boys—and later girls—often from the best old summer families. And then there is simply the sense, arrived at with not too much imagination, of the awkwardness of living in those tents wearing corsets, bustles, high collars, and neckties. In addition, the sexes sleeping one thin canvas curtain apart, using the same neighborhood privy, and no one ever being alone has seldom been more clearly suggested than in Inez Robinson's sketch. It was a paradox of Victorian life that extreme propriety regulated intimacy of a kind we rarely experience today—and perhaps the enforced intimacy explains, to a degree, the priggishness.

At the same time that life for many Chautauquans was continuing in the same old simple ways, the public face of the Assembly Grounds was becoming more and more sophisticated. Following the Columbian Exposition of 1893, a world's fair that took place in Chicago commemorating the four-hundredth anniversary of Columbus's first voyage to America, American cities began consciously to dignify their streets and parks with grand public buildings and monuments in neoclassical style. The grounds for the Chicago fair had been designed by Frederick Law Olmsted, the brilliant landscape architect who had made his name thirty-five years earlier with the plan for New York City's Central Park. The architects of record for the fair's buildings were Daniel Burnham and John Wellborn Root, who were masters of what was called the Beaux Arts school of architecture. This traditional approach was principally taught at the Ecole des Beaux-Arts in Paris, and it featured formal structures embellished with pillars and decorated pediments. At Chicago a "White City" of plaster Beaux Arts buildings, outlined in the new and exciting electric lights, was set gracefully in a park of Olmsted's design. So memorable was the result that all over the country triumphal arches—such as the one marking the termination of New York City's Fifth Avenue at Washington Square—and pillared libraries and post offices were erected; the trend was called the "City Beautiful."

At Chautauqua, despite the erection of the Amphitheater on a monumental scale matched only by the Athenaeum Hotel, which had risen on the lakefront the decade before, there had been no town planning since 1875. Olmsted himself had criticized the grid plan from that year as being too crowded. Consequently, in 1903 Albert Kelsey of Philadelphia, the president of the Architectural League of America, and Warren Manning, a well-known Boston landscape architect, were asked to

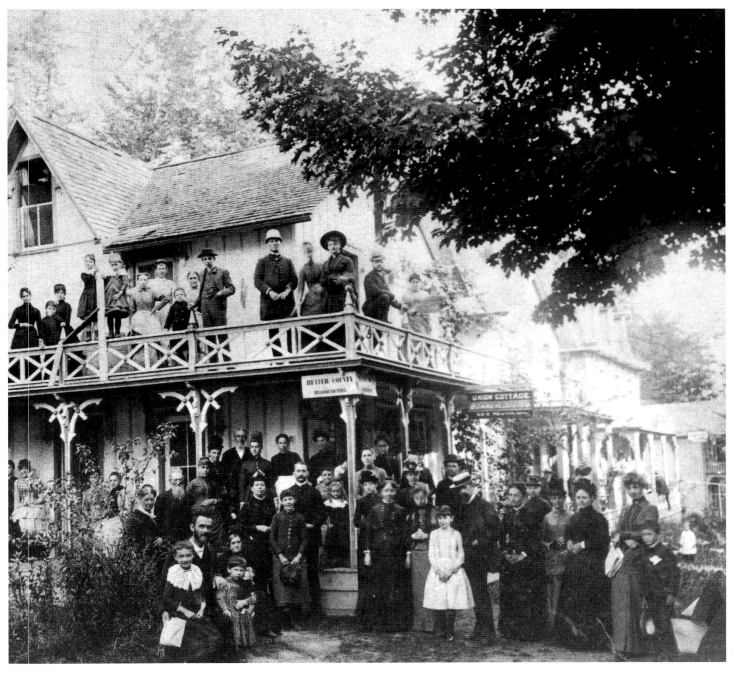

A typical Chautauqua boardinghouse. This one proudly calls itself "Beaver County [Pa.] Headquarters."
The cost of a week's lodging and meals was about $6 per person in around 1888, when this picture was taken.

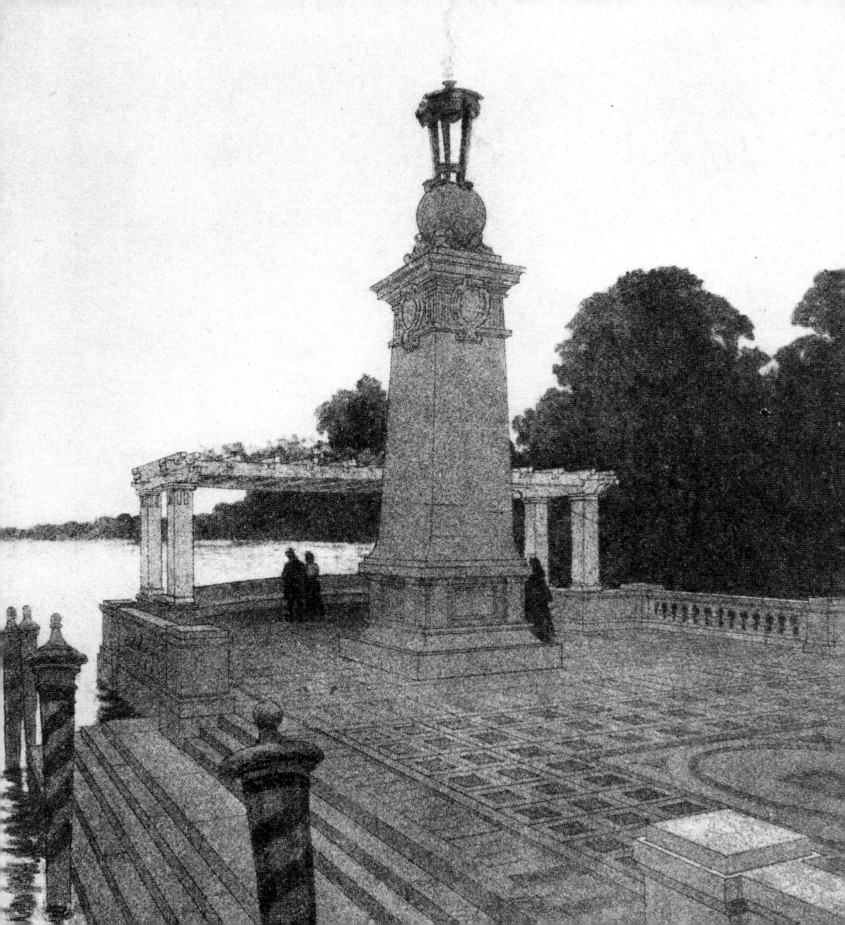

Opposite, left, and below: In 1903 Albert Kelsey of Philadelphia, the president of the Architectural League of America, and Warren Manning, a landscape architect from Boston, prepared an elaborate plan for Chautauqua in the style of the City Beautiful movement, which was popular at the time. Public buildings, formal walks, and landscaping were meant to dignify the Chautauqua Grounds, creating a miniature cityscape. Although only a few of the plans were realized, such structures as the Hall of Philosophy are the product of this study.

The plaza, in about 1910, with the Colonnade in the background and the ice cream pergola straight ahead, shows the influence of the City Beautiful plans.

prepare a plan to dignify the Chautauqua Grounds in a manner appropriate to the status of the organization. Manning, knowing the influence of Chautauqua's name, advocated making Chautauqua a model city. "By constantly seeing and gradually comprehending the growth and development of a preconceived plan," Manning wrote, "[residents and visitors] will come to recognize its importance to the public and private affairs of their homes."

William Lucy, associate dean of the School of Architecture of the University of Virginia, says in a recent paper that the plan, as drawn up, was on "a scale appropriate for a state capital." It included marble steps emerging from the water at the shore, with broad avenues leading away through the Grounds to pillared halls. Much of the plan was never realized, but certain features grace the Grounds to this day. The pedestrian streets, Vincent and Clark (known as the "brick walks" because of their surface), leading to the central square; that square itself; the pillared administration building called the Colonnade (1904); the pillared post office with an allée of trees along Clark Avenue in front of it (1909); and most of all the open-air, pillared Hall of Philosophy (1906) and the enclosed, pillared Hall of Christ (1909)—all are City Beautiful elements in the otherwise-dense townscape of Chautauqua.

By 1900 the Chautauqua Grounds covered 190 acres, and eight years later the organization owned 223 acres—approximately the same as the fenced area of the grounds today. Following the death of Lewis Miller in 1899, Clement Studebaker, the car manufacturer, was appointed president. Studebaker died a scant two years later in 1901; Wilson Day was president from 1902 to 1903,when Dr. W. H. Hickman, chancellor of DePauw University in Indiana, was appointed to the office. In 1906 Dr. Hickman left; and George E. Vincent, son of Bishop Vincent, professor, and soon-to-be dean of arts, literature and science

The pediment of the Hall of Christ. When the building was erected in 1909, it was part of the City Beautiful movement, which involved designing neoclassical buildings for Chautauqua and situating them in open plazas and squares. The Hall of Christ was placed higher than the buildings around it to symbolize the central position of Christianity at Chautauqua.

at the University of Chicago, was appointed president. In 1902 the Assembly had been formally reorganized as The Chautauqua Institution, and it became a nonprofit corporation under the direction of a twenty-four-member board of trustees with a charter from the State of New York.

By the first decade of the twentieth century, Chautauqua—in its organizational status and with its City Beautiful buildings dignifying the expanded Grounds—was recognizably the place it is today. Over the next thirty years, the program was broadened and transformed so that music and the arts would begin to outweigh the lecture and instructional components. The individual most responsible for this transformation, whose vision and impact on the Institution stands with that of Vincent and Miller, was a young lecturer in political science at the University of Chicago—the domain of William Rainey Harper and George Vincent. He arrived on the Grounds in 1905, and his name was Arthur Bestor.

The Chautauqua Post Office, built in 1909, contains the Book Store on its lower level. Its neoclassical revival architectural style was part of the City Beautiful movement of town planning introduced at Chautauqua during the first fifteen years of the century.

The poured concrete pillars of the Arts and Crafts Quadrangle, begun in 1909, are typical of its Shingle Style architecture. This is a fine example of a style more often seen in California in the work of such architects as Greene and Greene.

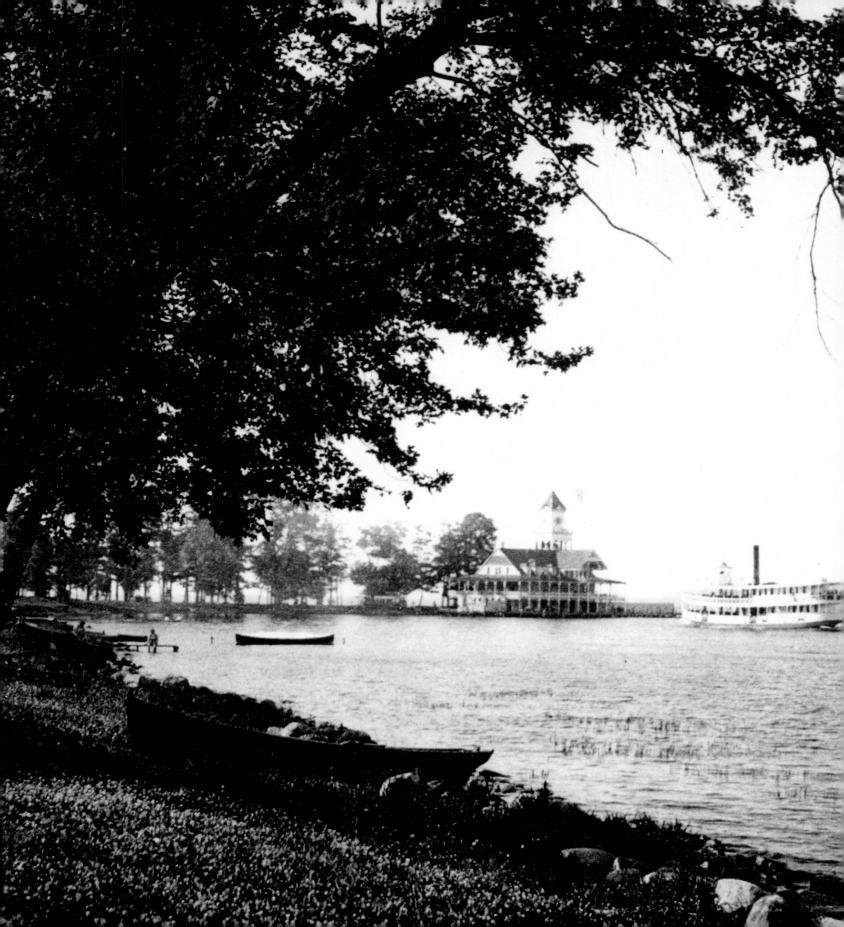

CHAPTER FIVE

Branching Out

Arthur Eugene Bestor was born in Illinois in 1879, the son of a Baptist minister. The family attended a Chautauqua Assembly at Monona Lake, Wisconsin, when Bestor was a boy, and his parents were both graduates of the CLSC class of 1892. Almost twenty-five years later, when Bestor was appointed to the presidency of The Chautauqua Institution, his mother wrote to him, "How little any of us thought or even dreamed, when you used to be so eager to take in everything at Monona Lake, that one day you would be so closely connected with Chautauqua work." The young man attended the University of Chicago, where he studied with both William Rainey Harper and George Vincent, graduating Phi Beta Kappa in 1901. He taught for two years at Franklin College in Indiana, where one of his students was a young woman named Jeanette Lemon, whom he would later marry. Bestor returned to the University of Chicago Extension Division—the program Harper had set up in unacknowledged imitation of the Chautauqua program—where he was appointed lecturer in political science. In the spring of 1905, he married Jeanette Lemon and began work that summer at Chautauqua, which he would balance with his winter lectureship until he began to work at Chautauqua full-time in 1912.

The bride and groom alighted in the spring of 1905 from a meandering local train (natives claimed that the line's initials "JW and NW" stood for "Jesus Wept and

No Wonder") on the lakeshore opposite the Institution. Seeing the stern of the lake steamer they had intended to board pulling steadily away, Bestor and another young husband rented a rowboat, and the two couples, the other wife holding a babe in arms, rowed across the calm blue surface of the water toward the castlelike Old Pier Building perched on the tip of Fair Point.

From this magical arrival at the citadel, Bestor stepped metaphorically right onto the lecture platform, delivering five lectures on American diplomacy in the first week of the Season. That first Season for Bestor was one of the most exciting in the Institution's history, because on August 11 President Theodore Roosevelt arrived on the Grounds and delivered an address. It was the first time since the visit of President Grant thirty years before that a sitting president had appeared at Chautauqua during the Season. (There would be only one more such occasion, when Franklin Delano Roosevelt spoke in the Amphitheater during the summer of 1936.)

Theodore Roosevelt arrived in the morning and was treated to a formal breakfast with 125 carefully selected Chautauquans in a brick Gothic-style lecture building called Higgins Hall. The menu for the "breakfast" makes heart-stopping reading in these temperate days: "Rocky Ford melon" was followed by "broiled chicken, escalloped Chautauqua Lake muskallonge, creamed potatoes, timbales of green peas, raspberry shortcake with whipped cream, coffee, Boston brown bread and Southern beaten biscuits." Jeanette Bestor, determined to take advantage of Chautauqua's every opportunity, had enrolled in a domestic science course appropriate for the young bride, and she and her fellow students served the meal. Jeanette was

Opposite: For Chautauqua's first forty-five years, most travelers arrived by train in Mayville, at the north end of the lake, or Jamestown, at the south end, and then took a lake steamer to the Grounds. The Pier Building, Chautauqua's main entrance at the time, was built in 1886 and torn down in 1916.

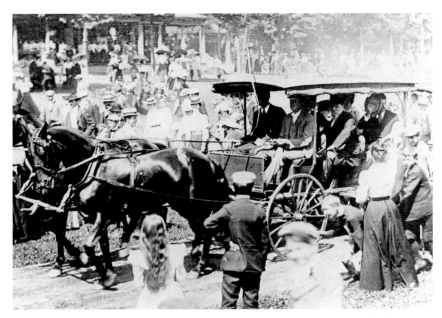

When President Theodore Roosevelt (in the back of the surrey, tipping his hat) visited Chautauqua in August 1905, he was served a "breakfast" including escallopped Chautauqua Lake muskallonge and raspberry shortcake. He called Chautauqua "typical of America at its best."

Little girls posed to greet Theodore Roosevelt, who visited Chautauqua as governor of New York in 1899. Wire hoops helped hold the topmost children in their places.

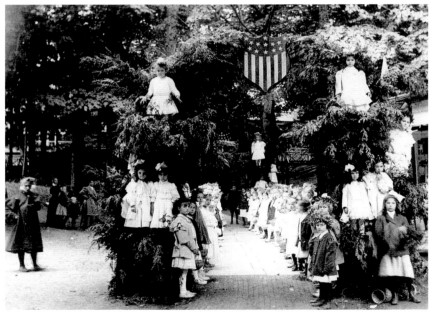

Opposite: President Theodore Roosevelt (center) with John Vincent (right), under the Romanesque arch of Chautauqua's Higgins Hall, where the presidential breakfast of 1905 was served.

Amelia Earhart (seated at center) poses in 1929 with President Arthur Bestor and his family. The famous aviator landed on the Chautauqua golf course.

chosen to wait on the president, and she would remember with amusement that another student, working behind the scenes in the kitchen, asked her to save Roosevelt's chicken bones so that the young woman could boil and keep them for a souvenir.

In his speech that morning, Roosevelt reputedly made the statement cherished by the Institution ever since—that "Chautauqua was typically American, in that it was typical of America at its best." The press later rephrased his remark as "Chautauqua is the most American thing in America," but, regardless, the president seemed to have acknowledged the central place of the Institution in American culture. The rest of his speech dealt with his invoking the Monroe Doctrine to justify, in the expansionist mode of the day, intervention in Santo Domingo.

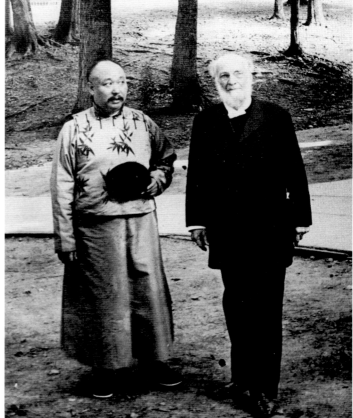

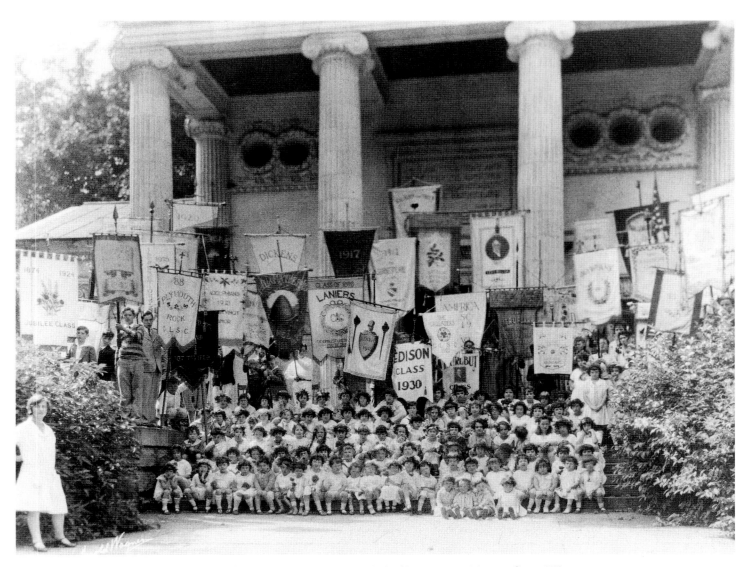

*A collection of banners up to the year 1930, with the obligatory Recognition Day flower children,
on the steps of the Hall of Christ. This building was designed by Paul Pelz, architect of the Library of Congress,
and dedicated in 1909. CLSC classes were often dedicated to famous people, living or dead, such as
Thomas Edison or Charles Dickens, or to Chautauqua heroes, such as Lewis Miller.*

*Opposite, bottom: Bishop Vincent remained as chancellor of Chautauqua, a ceremonial role created for him,
until his death in 1920. In 1915 he hosted social worker Jane Addams (left), and in 1904 he hosted a Chinese diplomat.*

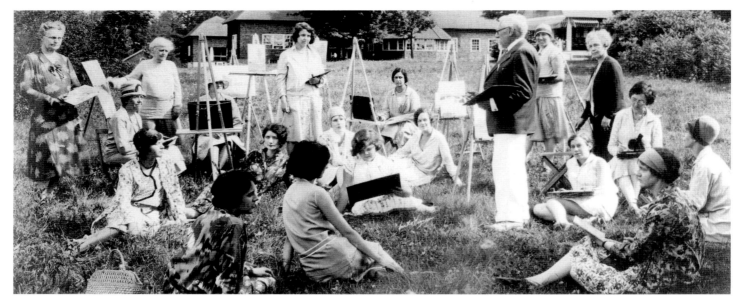

Painting and sculpture have been part of the Chautauqua schools program since its first days.
A painting class takes place in the 1920s near the Shingle Style Arts and Crafts Quadrangle.

The next year, 1906, George Vincent was appointed president of the Institution, and Arthur Bestor was made director. Soon Bestor's ambitious vision for expanding and enriching the program was felt. Music had been among Chautauqua's offerings from the beginning, but the focus was on choral—and often religious—music, or instruction. William Sherwood, a pianist who had his own school in Chicago, headed the piano department of the Chautauqua School of Music beginning in 1889, and in his twenty-two years at the Institution, he put together recitals that included performances of Bach, Mozart, Beethoven, Schubert, Schumann, and Chopin. In 1909, however, in an unprecedented move, conductor Walter Damrosch brought the New York Symphony to Chautauqua for a full-scale program.

Thomas Edison (whose wife, Mina, was the daughter of Chautauqua's cofounder Lewis Miller) had invented the phonograph in 1877. But early recording techniques were too primitive to be very effective for more than a voice or two singing with accompaniment or a few instru-ments playing. In those days before radio, therefore, only people who could get to concerts in major cities could hear symphonic music in any real way. A Willa Cather story of 1905 called "A Wagner Matinee" tells of a young Boston student being visited by his once-cultivated aunt who had married a prairie farmer; the young man takes his aunt, who was a music teacher before her marriage, to a concert of Wagner's music. The effect on the aunt of the long-lost aesthetic experience is devastating.

Bestor and Alfred Hallam, Chautauqua's director of music, less trusting of Chautauquans' musical sensitivity than Cather was of her prairie teacher's, were uncertain of the reception the symphony would get, and they prudent-ly scheduled a baseball game at the other end of the Grounds for the same time as the concert. But, in fact, as had happened before (notably when Dr. Vincent announced the formation of the CLSC, saying he hoped ten people would respond), the leaders had sold Chautauquans short. An hour before the concert was to begin, an estimated eight thousand people packed the

Amphitheater and stood four and five deep around the perimeter. The program began with the overture to *Mignon* and ended with "The Ride of the Valkyries"; and in between it contained Beethoven's Fifth Symphony. Damrosch said later that Chautauquans were "a fine audience to play for," adding that "they took the Fifth Symphony like lambs."

Once the hunger for symphonic music was aroused, it had to be satisfied. The next year, 1910, the orchestra was back, though it did not return after that for nine years. Victor Herbert, however, the composer of such popular operettas as *Babes in Toyland*, brought his own orchestra for a week in 1914; and for three years after that the Russian Symphony came to the Grounds and played concerts in series, including an all-Wagner program. Then in 1919 the New York Symphony returned for twelve concerts, and the next year it played a full six-week program, as it did annually (with the exception of one year) until 1929, when Chautauqua established its own symphony orchestra.

George Vincent had been simultaneously serving as president of Chautauqua and president of the University of Minnesota since 1910, which obviously put a heavy administrative burden on Arthur Bestor at Chautauqua. When Vincent resigned in 1915 to become president of the Rockefeller Foundation, Bestor assumed his position at Chautauqua, giving him the authority to match his responsibility. In 1924, Chautauqua's fiftieth anniversary, in a startlingly prescient report, Bestor wrote about the competition for the role of being a national podium that the Institution played. "One . . . serious liability is undoubtedly the changing conditions of American life. . . . Automobile travel has destroyed the popularity of many resorts," Bestor noted. His proposal to expand the arts component of the Chautauqua program, already well under way with the presence of the New York Symphony, allowed the Institution to survive and made it the model

for the summer arts festivals that would develop across the country over the next fifty years.

Before and during World War I, Chautauqua was in the vanguard in its reading and lecture programs. As early as 1909, the CLSC included on its list of books a pamphlet by Charles Beard entitled "European Sobriety in the Presence of the Balkan Crisis." In 1916 there was a symposium on "Preparedness for War or Peace," and one of the Amphitheater speakers was Scott Nearing, who would later become known as a socialist with an interest in education in Communist Russia. He said that capitalists profited from war and were trying to involve the United States. Once the United States had entered the war in April 1917, the Chautauqua platform, led by Dr. Bestor in the inaugural address of the Season, fully supported the effort. Bestor concluded his speech by saying farsightedly, "One of the results of this war must be the real internationalization of the world and the working out of institutions which will make war impossible."

After the war, new energy poured into developing and consolidating Chautauqua's music program, and a key figure in these changes was a young conductor of the New York Symphony, Albert Stoessel. Trained as a violinist, Stoessel conducted the New York Symphony for three weeks at Chautauqua in 1921 when he was only twenty-six. He was a performer and composer as well as conductor, and he had great imagination and executive ability. From 1923 until his sudden death at the age of forty-eight in 1943, Stoessel was the principal music figure at Chautauqua. He introduced Richard Strauss's *Death and Transfiguration* and Debussy's *L'Après-midi d'un faune* early in his conducting career at Chautauqua, along with more traditional works by Beethoven and Schubert, and by 1926 he was leading the orchestra in George Gershwin's *Rhapsody in Blue*. When the New York Symphony joined the New York Philharmonic in 1928 and would therefore no longer be able to come to

Albert Stoessel, conductor of the Chautauqua Symphony Orchestra from its inception in 1929 until his death in 1943, stands at his post in 1937, just before a concert that NBC radio is about to broadcast. The Chautauqua Literary and Scientific Circle motto for that year clearly proclaims the optimism that Chautauquans felt, having rescued themselves from financial receivership the year before.

People gather before an opera performance at Norton Hall. Opera, under the direction of Jay Lesenger since 1995, was first presented at Norton Hall in 1929, when the Art Deco–style building was completed.

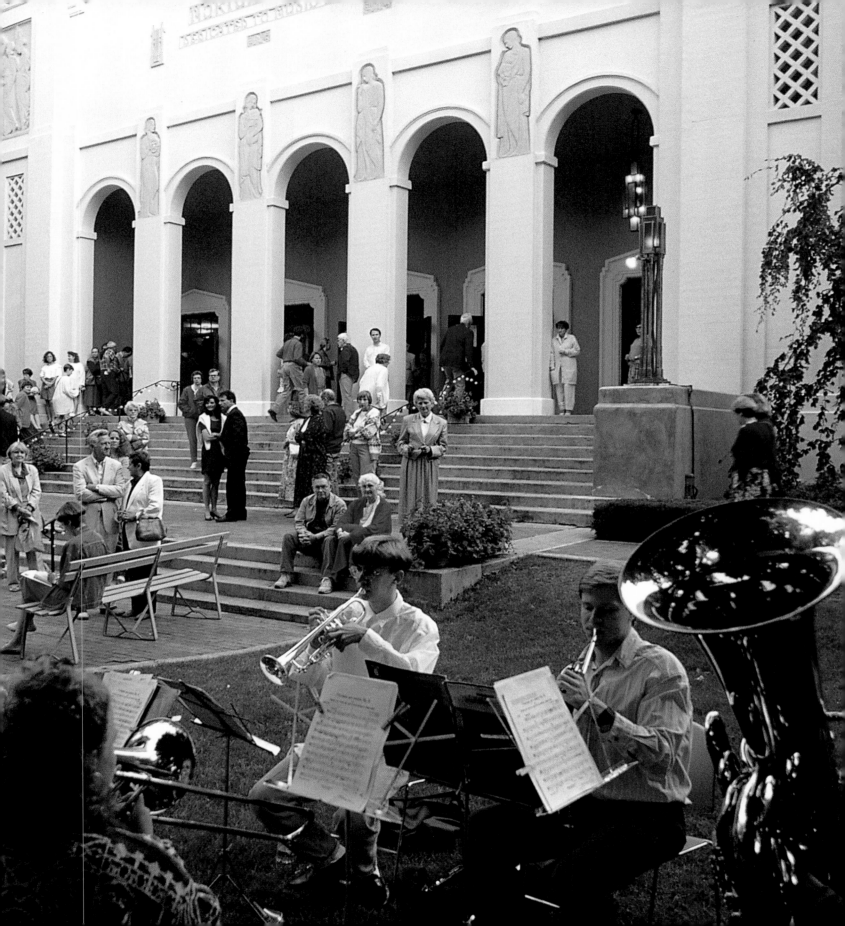

Chautauqua, Stoessel organized the Chautauqua Symphony Orchestra with a group of musicians, including some who had left the New York Symphony.

For the 1929 Season, Stoessel also created a professional opera company, which inaugurated Norton Hall, a new, enclosed thirteen-hundred-seat auditorium, with a performance of Friedrich von Flotow's *Martha*. Built with a $100,000 gift given by Mrs. O. W. Norton of Chicago, a longtime Chautauquan whose family would be part of the Institution's life for generations, Norton Hall is a poured-concrete building in high Art Deco style. Stoessel was deeply involved with the Juilliard School of Music in New York and soon became the head of its opera department and orchestra, and so he brought Alfredo Valenti from Juilliard to be production director of the Chautauqua opera. Stoessel subscribed to three principles of opera that had first been articulated at Chautauqua by Vladimir Rosing in 1926. These principles, then gaining credibility in America, were: operas were to be sung in English; acting as well as singing was to be stressed; and young American singers should be given roles to encourage native talent. Young singers who got their break at Chautauqua and went on to the Metropolitan Opera and the stage included Helen Jepson, Josephine Antoine, Julius Huehn, Frances Bible, and Charles Kullman.

Attending the first performance of *Martha* in the summer of 1929 were Mr. and Mrs. Thomas Edison, Mr. and Mrs. Henry Ford, Adolph Ochs (publisher of *The New York Times*), and all the Chautauqua dignitaries, including Dr. and Mrs. Arthur Bestor. The occasion was a celebration of the centennial of the birth of Chautauqua cofounder Lewis Miller, Mrs. Edison's father, and the fiftieth anniversary of Edison's invention of the lightbulb. Called the Festival of Light, the program included a luncheon at the Chautauqua Women's Club building where Mrs. Edison and Mrs. Ford were photographed holding nosegays; performances by the Chautauqua Symphony

Orchestra in the Amphitheater; a symposium at which Ford, Edison, and Ochs answered written questions; and the inaugural performance of the opera at Norton Hall.

With concerts by the professional symphony, a junior symphony composed of music students, five to seven operas each Season, a choir, and a string quartet playing chamber music, Chautauqua had become a festival with a scale and depth known before only in Europe. In the late 1930s, when Nazi exclusion of Jews from performing at the Salzburg Festival caused many American performers to decline invitations there in protest, the Chautauqua publicity director wrote a letter to *The New York Times* pointing out that America had its own Salzburg: "Symphonies and operas alone would make a festival, but Chautauqua [has] in addition a choir of 200, a choral festival of more than 500 voices, chamber music recitals, piano recitals . . . daily organ recitals . . . [and] lectures on music." It is worth noting that the Tanglewood and Saratoga music festivals were started at this time; presumably the rupture with the German and Austrian festivals had a great deal to do with the timing.

Rounding out the performance arts at Chautauqua was the Cleveland Playhouse, which began a more than fifty-year run of summer repertory theater in 1930 with a performance of *The Importance of Being Earnest*. The theater shared Norton Hall with the opera in a stagehand's nightmare of alternating performances on alternating nights, but it made for an extraordinary richness of possibilities for every Chautauquan. In addition to the Wilde play, the first season of theater saw George Bernard Shaw's *Candida* and Eugene ONeill's *Beyond the Horizon*; this balance of classic and contemporary theater would last until the late 1970s. In one Season in the 1950s, for instance, the repertoire included Chekhov's *Uncle Vanya*, *The Diary of Anne Frank*, *Macbeth*, *The Magnificent Yankee*—a dramatization of the life of Oliver Wendell Holmes—and Sean O'Casey's *Pictures in the Hallway*.

Theodore Morrison, in *Chautauqua*, discusses an essay written for the *Yale Review* in 1929 by Lucien Price, a Boston journalist who had spent childhood summers at Chautauqua and returned as an adult. Price uses English poet Matthew Arnold's theme of Hebraism versus Hellenism in Western culture as a way of describing the development of the Institution and says, "Thus, at the start, Judea was the main tent and Hellas the side show. But as the years went on, Judea became the side show and Hellas the main tent." Morrison approves of this analysis and says, "the lines of growth Chautauqua . . . followed were implicit in the ideas that John Heyl Vincent cherished from the beginning. . . . In his aplomb toward theological controversy, his confidence in the value of all knowledge, his instinct for showmanship, his belief in continued personal growth, the development of Chautauqua was inherent."

Unfortunately, all this expansion came at a cost. The Institution had followed a balanced budget policy for its first twenty years, but the coincidence of building the new Amphitheater in 1893 and the effects of the Panic of 1893 put it in debt. Buying *The Chautauquan Magazine* and the book publishing company associated with the CLSC in 1900, along with the construction of new buildings of the City Beautiful plan in the first decade of twentieth century, increased the debt. Just after World War I, Arthur Bestor announced a Comprehensive Plan to raise $500,000, and John D. Rockefeller offered a 20 percent matching gift as part of the total. The campaign ended in 1921, with only half the money in hand.

The outline of this campaign to seek financial aid says a lot about Arthur Bestor's leadership. To the extent that it was the first campaign of planned giving the Institution undertook, it reflects great vision in a day when cultural organizations tended to be either supported by their ticket sales or a few protective donors. Soliciting money from the entire Chautauqua constituency and from such outside

In 1929 Chautauqua celebrated the centennial of the birth of its cofounder Lewis Miller and the fiftieth anniversary of the invention of the electric lightbulb by Miller's son-in-law, Thomas Edison. Edison attended the Festival of Light accompanied by Henry Ford and New York Times *publisher Adolph Ochs. On the porch of the new Women's Clubhouse, Mrs. Edison (left) poses with Mrs. Ford (second from left) and other ladies, presided over by the Women's Club president, Mrs. Percy V. Pennybacker.*

sources as the Rockefellers would leave Chautauqua enriched, independent, and with its direction in the hands of the trustees and administrators. The money was needed to reduce existing debt, and, although some was used for that purpose, much went into expanding the program. During the Seasons of 1926, 1927, and 1928, there was a new campaign launched to raise $100,000 for capital improvements. Again Mr. Rockefeller stepped in, and the goal was met. But this was not enough: In 1928, the debt had risen to $500,000, and it was refinanced by the sale of ten-year bonds with an annual interest rate of $5\frac{1}{2}$ percent. Without the expansion and redirection of the program that took place in the 1920s, for which expanded facilities were necessary, Chautauqua would not have survived. But the debt assumed to effect this change would nearly destroy Chautauqua in the 1930s.

Official
Newspaper
of
Chautauqua

The Chautauquan Daily

Vol. LX., No. 36

Official
Program
on
Page Eleven

CHAUTAUQUA, N. Y., FRIDAY, AUGUST 14, 1936

Price Five Cents

President Roosevelt To Address Chautauqua Audience Toda

Chautauqua Ready To Handle Throng Expected For Talk

Visitors Are Urged To Observe Regulations Drawn Up by Institution Officials for Evening Amphitheater Address.

President Roosevelt's visit here tonight has necessitated preparatory measures for handling the large crowd, and Chautauqua officials have asked, for the mutual convenience of all, that the regulations be carefully observed.

The Amphitheater will be roped off until 7 p. m., at which time available seats will be filled. The overflow will be able to hear the president's address perfectly thru the enlarged public address system now installed. No camp chairs will be allowed within the Amphitheater.

Governor Herbert H. Lehman will be seated on the platform with the president and other notables. Seats in the choir loft will be held for members of the choir, the Summer Schools faculty, the Chautauqua Repertory Theater, the Opera Company, officials of the Bird and Tree and Woman's Clubs, and holders of special tickets.

Prior to the President's address George William Volkel will play selections on the organ and Walter Howe will lead the audience in community singing.

Other events on the day's program which are open to the general public include the lecture series by Dr. James McDonald at 10:45 a. m. in the Amphitheater, a baseball game on the diamond at the South end of the Grounds at 3 p. m., and the presentation of Gilbert and Sullivan's opera, "Pirates of Penzance," by the Chautauqua Opera Association at

First Man of the Land in Action

(Photo by Margaret Bourke-White, Copyright, 1935, NEA Service, Inc.)

President Franklin Delano Roosevelt who will deliver his fourth address at Chautauqua tonight, speaking on the international relations of the United States.

Chief Executive To Take Amphitheater Platform at 8 P. M.

Speaker, Appearing Fourth Time During Political Career. Will Third President to Spe Here During Term of Office.

When President Franklin D. Roosevelt steps to the front of the Amphitheater platform at 8 p. m. today, will be the third time a president the United States has addressed Chautauqua audience during his te of office and the fourth time Presid Roosevelt himself has spoken Chautauqua.

The Chief Executive will be sixth president of the United Sta to speak here and the seventh president to visit Chautauqua.

President Franklin Roosevelt speaking on a topic of world-w interest, "Foreign Affairs," reports which will be circulated and ha considerable effect on areas all o the world such as war-torn Spa Russia, Japan, South America, Afri as well as in the United States.

President Roosevelt's cousin, late Theodore Roosevelt, who spe at Chautauqua in 1905 when he w just completing the unexpired term the assassinated McKinley, also spe on a great topic of moment and ports of his address were widely c culated and commented upon at time.

President "Teddy" Roosevelt h faithfully carried out, up to this tim the policies of his predecessor, upon the emergence of campaign a second term, he came out w pointed views of his own which he not hesitate to express. The Cha tauqua speech was one of the fi proclaiming his new views.

President Theodore Roosevelt

League Now Hinges On Ability To Avert War

Speaker Asks Change In Educational Plan

Dr. McDonald Displays

National P T A President

"I Hate War"

It is not fair to say that Chautauqua's near financial collapse in 1933 was entirely the result of the frivolous pursuit of prosperity of the 1920s. The redevelopment of the Chautauqua program and the expansion of its facilities were essential for it to survive as an institution with popular relevance and appeal. It is true, however, that the national climate of seemingly unending well-being tempted Arthur Bestor to pursue his vision to its fullest extent. Theodore Morrison writes, "Some Chautauquans at the time suspected that the trustees put such implicit confidence in President Bestor that they approved his capital commitments without looking closely enough into the

Opposite: President Roosevelt's visit made front-page news in 1936.

Overleaf: Dr. Arthur Bestor, Chautauqua president from 1915 to 1944, leads the Amphitheater audience in waving dollar bills on Old First Night, the annual program that commemorates Chautauqua's founding and exhorts Chautauquans to contribute financially to the Institution. In the 1930s, when this scene took place, Chautauquans were determined to overcome the financial threat the Depression had brought.

problems of funding." That this was not unusual is attested to by Samuel Eliot Morison in his *Oxford History of the American People*, where he notes that "optimism, justified in the early 1920s, had been carried to extremes . . . on the part of leaders in business, finance, politics, and the universities."

Bestor's daughter, Mary Frances Cram, says in her clear-sighted memoir, *Chautauqua Salute*, that "figures for gate receipts during the period give a vivid picture. From 1926 through 1929 there had been a steady increase in receipts from $102,407 to $105,427. But in 1930 the total fell to $94,407, in 1931 it was $88,521, and by 1932 it was down to $61,584. In 1933 the alarming figure of $48,957 had been reached. With income so reduced, the season closed unable to meet the interest on the bonds." Chautauqua's total debt, calculated at the end of the 1933 Season, had climbed to $785,000. It was in 1932 that the nadir of the economy was reached; nationally, 12 million people—25 percent of the normal workforce—were unemployed. Naturally, Chautauqua, a leisure interest of

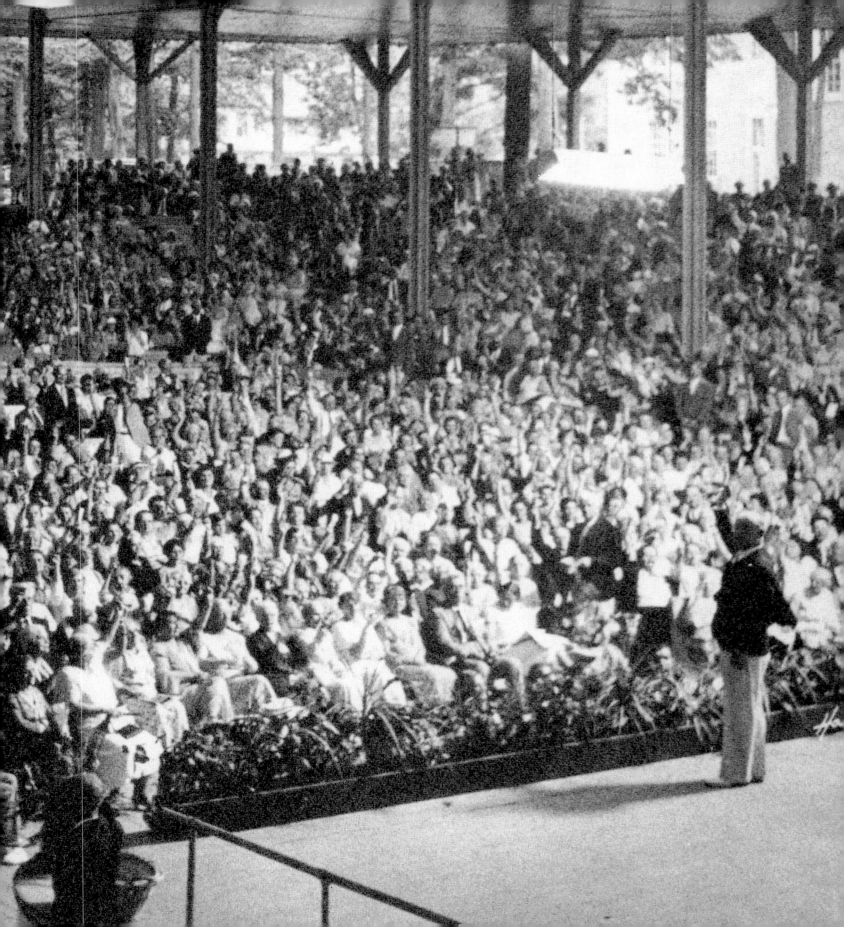

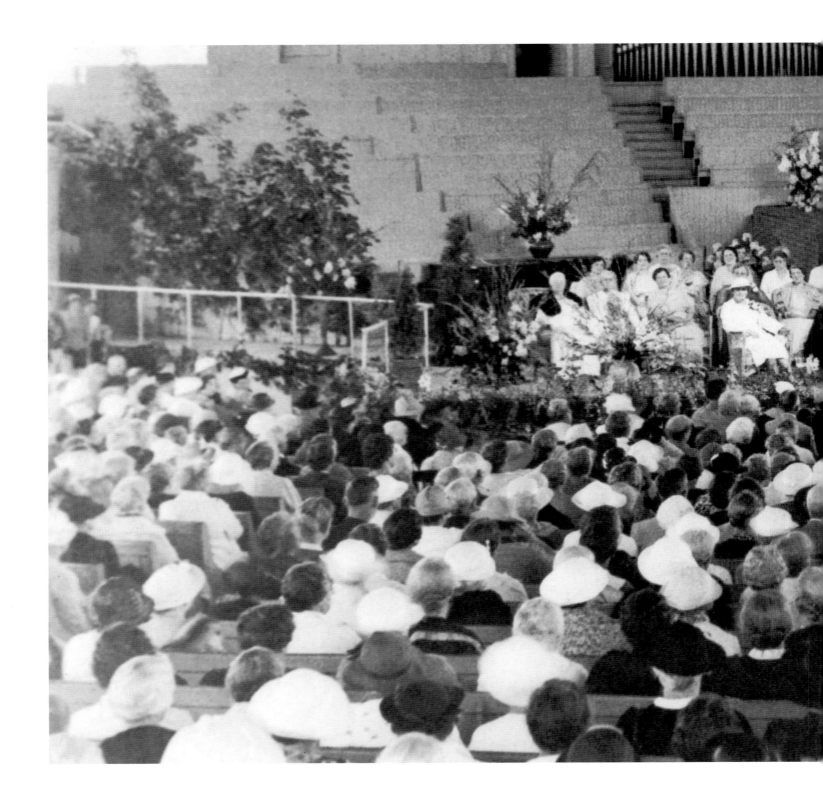

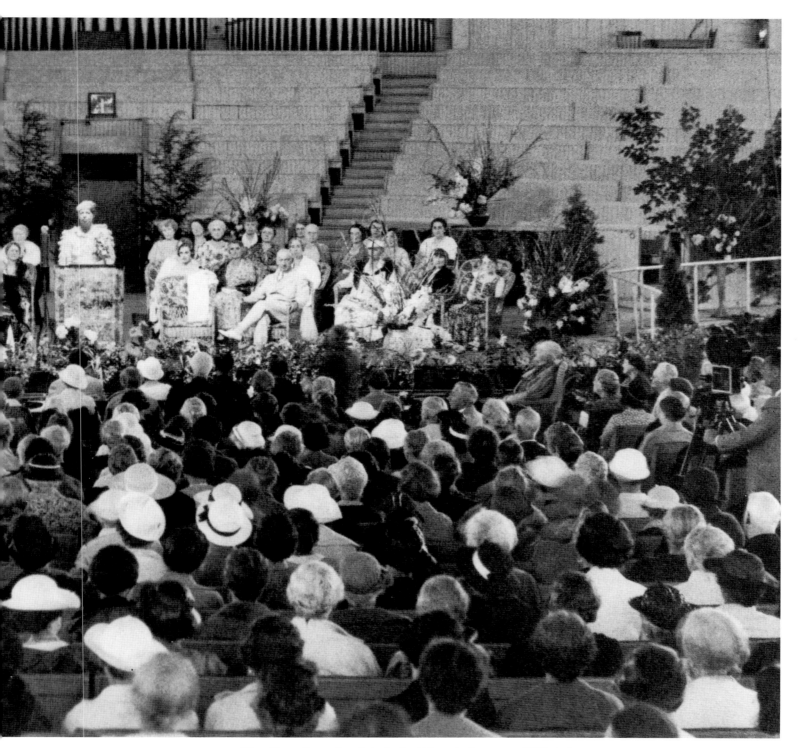

*When Eleanor Roosevelt spoke in the Amphitheater in the summer of 1933, during one
of her seven visits to the Grounds, she said, "All change [in the world] probably arose in the first place because
of women." Despite the strength of the Chautauqua program, that Depression year found gate receipts
so low that it was doubtful whether the Institution could continue into another Season.*

the middle class, felt the effects most drastically during the next summer.

At the end of the 1933 Season, Mary Frances Cram remembers that her father took the symbolically painful step of not announcing the dates for the following Season when the Assembly was traditionally closed with three taps of the president's gavel. The Chautauqua trustees that autumn petitioned the court for a receivership, preparatory to bankruptcy proceedings, and on December 21, 1933, the Institution was placed into the hands of two sympathetic receivers, Alburn Skinner, chairman of the board of trustees, and Dr. Charles Haskin, Chautauqua's resident physician. In the meantime, the Chautauqua Reorganization Corporation, composed of Chautauqua trustees and others, under the direction of Samuel M. Hazlett, a Chautauquan and a Pittsburgh lawyer, was formed. The Reorganization Corporation was an independent corporation, pledged to underwrite the cost of the 1934 Season, and ultimately "to acquire all claims against Chautauqua by purchase, by gift or any other means so that by the end of three years it would be the sole creditor of Chautauqua Institution."

Hazlett was determined in his efforts. Major gifts were solicited, and the 1934 Season's program was conducted without financial loss. Imaginative schemes were formed. The ninety-nine-year lease held by most Chautauqua property owners was converted to a permanent deed for a charge of 20 percent of the assessed value of the property. Complementing the sale of real property to private cottage owners, trees on the Grounds, Amphitheater benches, and public buildings were sold symbolically and affixed with little plaques bearing the names of the "buyers" or of people they wished to honor or memorialize. The Corporation went on to guarantee the 1935 Season. By the summer of 1935, $304,000 was also pledged toward paying off the debt, but the bondholders nonetheless met with the Corporation and the receivers in June in Buffalo intending to insist on foreclosure.

The Corporation secured a delay, dependent on one substantial payment by September 1 and another by April 1936. The deadline for the complete payment was the end of August 1936. At the beginning of the 1936 Season, there was still $150,000 to raise, and by the first week of August, $100,000 was still needed. Mr. and Mrs. Ralph Norton, whose family had built Norton Hall, offered to donate one dollar for every two given by others, up to $35,000. This total would take care of the outstanding amount, but the Norton gift would take effect only if the entire $70,000 was raised. On August 9 *The Chautauquan Daily* pointed out that Chautauqua was still $50,000 short of its goal, and it assured readers that no secret fund existed. On August 20, Hazlett declared, "We shall either succeed or fail by the last day of August," and announced that there was still $37,000 to go. On August 28, the next-to-last day of the 1936 Season, Mrs. Percy V. Pennybacker, a Texas dowager who directed the Women's Club with an iron hand in a velvet glove, approached Chautauqua's old friend John D. Rockefeller, Jr., and two blasts of the town's fire siren signaled the close of a successful campaign. Chautauqua had been saved.

It's impossible to know at this distance how sanguine the Corporation was about finding the final money, but it is certain that the saving of Chautauqua was a real cliffhanger, and it is an extraordinary proof of the devotion of the constituency that such a reversal of bad fortune could happen.

It is equally extraordinary, however, and a potent reason for that devotion, to see what a vital program Chautauqua continued to present in the throes of its nearly mortal agony through those years. In 1933, the Season of the all-time low gate receipts, Eleanor Roosevelt, whose husband had been newly inaugurated as president of the United States, made one of seven visits to Chautauqua. She told a packed Amphitheater (with three

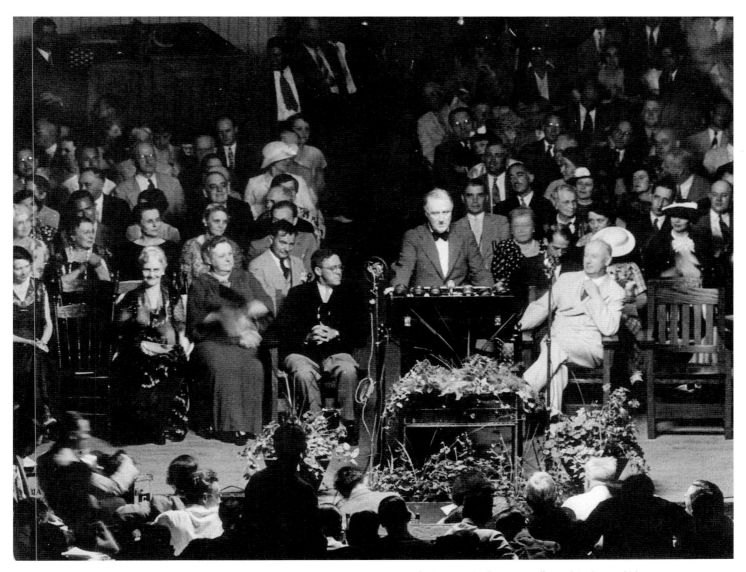

On August 14, 1936, President Franklin Delano Roosevelt made what came to be known as his "I Hate War" speech in the Amphitheater. Three other candidates for president—Alfred Landon, Norman Thomas, and D. Leigh Colvin—also spoke at Chautauqua that summer, even as the Institution was waiting to find out whether the previous three years' fund-raising would save it from bankruptcy.

women stenographers—a deliberate and symbolic choice—recording the speech) that "all change [in the world] probably arose in the first place because of women," and went on to declare "I think the real reason . . . women have a responsibility today is because they have the opportunity of directing some of the changes [necessary in the world, and these must] go hand in hand with a revival of real religion . . . for real religion is based on the idea of sacrifice of the individual for the good of the many."

Some memories by lifelong Chautauquans of Mrs. Roosevelt's visit suggest her charm and political savvy. Mary Frances Cram had just graduated from Vassar where she had stayed on to teach education courses, and, with all the assurance of a young sophisticate, she told her mother, Jeanette Bestor, who was going to serve a luncheon for Mrs. Roosevelt at the President's Cottage, "Mother, you *cannot* have those heavy dishes like fried chicken and potato salad that you always serve. You have to have something *elegant* like cold poached salmon with dill sauce."

Mrs. Bestor replied that that was all well and good, but neither she nor the cook knew how to make cold poached salmon with dill sauce.

"I'll make it," said Mary Frances.

Not willing to stifle her daughter's creativity, Mrs. Bestor agreed. The salmon got poached all right, with the cook's help, but when Mary Frances was vigorously beating the sour cream and dill together, the handheld beater slipped, the bowl crashed onto the floor, and there was dill sauce all over Mary Frances and much of the kitchen. What to do? Mrs. Bestor had gone upstairs to change her dress, and the cook had gone upstairs to change her apron.

"MOTHER! MOTHER!," screamed Mary Frances, running into the living room, where she found Mrs. Roosevelt, who had arrived early, serenely sitting in a wicker chair flipping through a magazine. Apprised of the disaster, Mrs. Roosevelt said, "My dear, I will take care of the situation," and strode into the kitchen, thus extending her reputation for being a mythic fixer, although it is generally known today that, as far as kitchen matters went, she could barely boil water.

The gap between the Roosevelt family's private ethics, however, and those of the average Chautauquan was indicated in the packed Amphitheater after Mrs. Roosevelt's speech when she was asked why her husband wanted to repeal Prohibition and what was her attitude about drinking? "The President and I both feel strongly that we want our sons to drink like gentlemen and we have tried to teach them that," said Eleanor to a stunned and disapproving hush. Longtime Chautauquan Robert Osburn remembers his mother coming home from the Amp, saying how awful that was and that she would never, never vote for Roosevelt—which was unlikely for a lifelong Republican from Chicago anyway.

The Roosevelts, however, clearly understood that it was important for them to have the bedrock American constituency that Chautauqua represented on their side as much as possible. In a triumph of snob appeal and diplomacy, aided by Dr. Bestor's marketing skills, Eleanor Roosevelt invited the entire membership of the Chautauqua Women's Club to tea at the White House in January of 1934. Robert Osburn's mother, whom he remembers as being timid about going alone to downtown Chicago from their home in the suburbs—and despite her disapproval of Mrs. Roosevelt's standards of drinking—went by herself on the train to Washington to enjoy, with several hundred others, the First Lady's hospitality.

As an example of Chautauqua's determination to appreciate all points of view, later in the Season of 1933, Norman Thomas, the Socialist candidate in the presidential election the preceding year, spoke on "The New Deal from a Socialist Viewpoint." Morrison's history says that Thomas "saw three possibilities for the United States

under the National Recovery Act and other New Deal measures. One was disaster, a second was fascism, and a third the chance that the New Deal might smooth the way toward socialism. 'I want to pay ungrudging tribute,' [Thomas] said, 'to the energy and courage with which the President has pushed action. He has given the country new hope.'" Morrison then notes that the *Daily* reported that "a spirited question period followed from the heavily Republican audience."

Chautauqua's habit of dealing with issues in a timely, and even prescient, way was demonstrated on July 11, 1933, just six months after Hitler had assumed power in Germany. James G. McDonald, chairman of the executive committee of the national Foreign Policy Association, spoke to the effect that Hitler was not being taken seriously enough. He said, "The Jewish problem under the Nazi regime in Germany is not primarily a Jewish problem at all; the Jews are just the victims. It is a Christian problem, because the persecution is being carried on in the name of Christianity."

Throughout this Season and the anxious next two, the other lecturers were equally trenchant, and the full complement of operas, symphony concerts, chamber music, and plays was kept up. Then in 1936 Dr. Bestor played his trump card: Simultaneously with the tension of waiting through those August days to see whether Chautauqua would be saved or lost by a few dollars, President Franklin Delano Roosevelt, at Dr. Bestor's invitation, came to the Amphitheater and delivered what would afterward be known as his "I Hate War" speech.

The Chautauquan Daily began on August 12 to prepare Chautauquans for the appearance of the president on Friday evening, August 14. As always, no seats in the Amphitheater would be reserved and "no camp chairs will be allowed within the Amphitheater," but there would be a public address system set up to carry Roosevelt's voice to the surrounding areas. Chautauquans, who customarily,

trustingly, left their doors open and unlocked, were told to lock them with so many unknown visitors on the Grounds—and New Dealers at that, may have been the implication. People who were shopping off the Grounds for groceries were urged to get them in by early Friday, and people leaving the Grounds were told to be off by the same time. Newsreel cameras would be on hand to record the President's speech for thirty thousand movie screens; state troopers, National Guardsmen, and plainclothesmen would all be on the Grounds and on the alert.

The presidential visit began at 7:29 in the evening when Roosevelt's train pulled into the station at Mayville, three miles away. The chief executive was met by Dr. Bestor and a group of Chautauqua dignitaries; a representative of the County American Legion presented him with a large standard of Lady Eleanor roses and gave a corsage to Missy LeHand, the president's well-known secretary. The burden of Roosevelt's speech was stated at the beginning with his declaration that "a few days ago I was asked what the subject of this talk would be; and I replied that for two good reasons I wanted to discuss the subject of peace: First, because it is eminently appropriate in Chautauqua and, secondly, because in the hurly-burly of domestic politics it is important that our people should not overlook problems and issues which, though they lie beyond our borders, may, and probably will, have a vital influence on the United States of the future. . . . I am more concerned and less cheerful about international world conditions than about our immediate domestic prospects."

Roosevelt continued with warnings about the threat of war, while saying that the United States must choose peace. He gave the caveat, "We are not isolationists, except insofar as we seek to isolate ourselves completely from war. Yet we must remember that so long as war exists on earth there will be some danger that even the nation which most ardently desires peace may be drawn into war."

In the most stirring passage of the speech, the president ringingly declared, "I have seen war. I have seen war on land and sea. I have seen blood running from the wounded. I have seen men coughing out their gassed lungs. . . . I have seen cities destroyed. . . . I have seen children starving. I have seen the agony of mothers and wives. I hate war."

Three years before Hitler marched into Poland and five years before Pearl Harbor, the speech was a hopeful pledge of faith, combined with a warning of the possibilities of realpolitik. At its conclusion—to wild applause—the president of the United States was driven to the home of the president of Chautauqua for a brief reception. Bestor's daughter remembers that when the incorrigibly charming Roosevelt, who had spoken at Chautauqua twice before, was lifted in his wheelchair onto her parents' porch, he "turned his famous smile upon my mother and said, 'Ah, Mrs. Bestor, I always remember how cool your lovely home is.'"

Although the most famous, Roosevelt was not the only presidential candidate to brave heat, humidity, and train cinders in that election year to speak from the Chautauqua platform. The three other major candidates, D. Leigh Colvin for the Prohibition party; Norman Thomas, the Socialist; and Alfred Landon, the Republican, all reaffirmed Chautauqua's earliest role as a national podium. The fact that two of the candidates, Thomas and Landon, were childhood Chautauquans also suggested that Chautauqua was still representative of mainstream American culture and a breeding ground for the best of it. Thomas, who had been a Presbyterian minister and an editor of *The Nation*, had sold *The Chautauquan Daily* on the Grounds as a boy, and Landon had spent his youthful summers in the cottage built by his minister grandfather in 1876 a few doors away from Lewis Miller's Swiss chalet.

Not only in its major platform personalities, but in all aspects, the program for that summer of 1936 gives every indication of vigor. For Saturday, August 15, for instance, the day after Roosevelt spoke, the day began at 8:30 with choir rehearsal in the Amphitheater, open to any passerby who cared to stop and listen; there was a lecture on health in the Hall of Philosophy at 9:30 and simultaneously one on American Indian lore in another open-air hall; at 10:30 a children's concert was given by the Chautauqua Symphony Orchestra, broadcast live over NBC Radio. After a break for lunch, Dr. John W. Studebaker, United States commissioner of education, spoke on "The Federal Government and Education" in the Amphitheater at 2:15; and at 2:30 there was the first of three screenings of the day of *Three Wise Guys* with Betty Furness and Robert Young in Higgins Hall, the lecture-hall-turned-movie theater where this President Roosevelt's cousin Theodore had had that famous breakfast on his presidential visit more than thirty years earlier. The formidable Mrs. Percy V. Pennybacker in her capacity as president of the Women's Club presented a concert by Earle Spicer, baritone, in the Hall of Philosophy at 3:30, while at 3:45 the Athletic Club was hosting a baseball game down at the baseball diamond in the south end of the Grounds. The Daughters of the American Revolution met at 4:00. At 4:30 the Chautauqua Chamber Music Society was playing in Norton Memorial Hall. At 7:00 there was a children's story hour. And at 8:15 the Chautauqua Symphony Orchestra presented an all-Russian program in the Amphitheater, while at Norton Hall the Cleveland Playhouse put on *The Bishop Misbehaves*.

For a sense of what the crowded, festive, and wholesome daily life was like on the Grounds for the average Chautauquan, we have oral histories recorded on tape by Alfreda Irwin. Mrs. Dorothy Boal Bierly and her mother, Mrs. Lena Boal, whose family had first bought property at Chautauqua in 1876, ran the flourishing Cary Hotel from 1906 to 1954. The Cary was one of four or five of the

larger hotels that were privately owned, though not as big—or grand—as the Institution-owned Athenaeum. Housed in two large clapboard buildings with rambling porches on opposite sides of a narrow street, the Cary had seventy rooms, sixty employees during the (then) eight-week Season, and could seat 144 people in the dining room. "We would serve over three hundred people for Sunday dinner," remembered Mrs. Bierly proudly.

The day of President Roosevelt's visit, August 14, 1936, the Cary ran its standard ad in the *Daily* for its 75-cent dinner served from 4:30 to 7:00: fruit cocktail or spiced melon relish first; fried muskellunge, roast rib of prime beef, or baked chicken pie next with buttered new potatoes, garden string beans, buttered peas, and hearts of lettuce salad; French roll; and apple pie with cheese or vanilla ice cream and chocolate cake for dessert. The beverage choices were tea, iced tea, coffee, iced coffee, or milk. All of this with linen tablecloths and napkins and pretty college girls to serve.

The work to maintain such an establishment defeats the contemporary appliance-addicted imagination. In May, two months before the season opened, Mrs. Bierly and her mother brought three laundresses, four utility men, and a couple of chambermaids—all black—with them from Florida. As the white college student help came on board a month later, things began to open up. It took two months to open completely and then one month to close. "The laundresses washed, starched, and stretched the curtains for three weeks after the Season," said Mrs. Bierly. "There were different sizes in each room."

The guests were a typical Chautauqua mix: a retired judge and his wife from Oklahoma City who were remembered because their two little grandsons were lost in a cave for five days back in Oklahoma; schoolteachers; the wives and children of lawyers and doctors and insurance salesmen from little towns in Pennsylvania and Ohio. But there were others. "Opera singers' and artists' hours

don't agree with Chautauqua hours," said Mrs. Bierly with what one can imagine was a shake of the head. "And they don't eat at the same time." In the summer of 1925, George Gershwin stayed at the Cary for three weeks, composing his Concerto in F, which had been commissioned by Walter Damrosch. "He would come in after everybody had gone to bed," said Mrs. Bierly, "and I would be waiting to turn out the lights. He would want to talk. We didn't agree on too much."

The Bierlys followed the Chautauqua custom of partaking in all the activities they could. "We always went to the opera and the plays. In those days you dressed for the opera [that is, the women wore long evening dresses]." And on the night of her speech, Mrs. Roosevelt came up the aisle at Norton Hall and stopped to tell Mrs. Bierly's eight-year-old daughter how pretty her dress was.

This anecdote makes an interesting point, by implication, about Chautauqua's social fluidity. As an idealized country village, Chautauqua offered an opportunity for its people, many of them with small-town roots, to achieve a social presence they might not have had at home. Admittedly until well after World War II you had to be a white Anglo-Saxon Protestant—and unless you were a southerner you probably had to be a Republican—but within those boundaries, there was an extraordinary degree of mixing among Chautauquans of varying financial backgrounds. College girls and boys from the best old summer families waited tables at the hotels, and school-teachers and local business proprietors went to the opera. Mrs. Edison and the Heinzes sat on the open benches of the Amphitheater with the art-school instructor and the clerk in the grocery store.

Because of the ephemeral nature of the Season, there has always been a make-believe quality to spending time on the grounds. At Chautauqua, in a setting that feels like home, the very air is imbued with a sense that anything is possible.

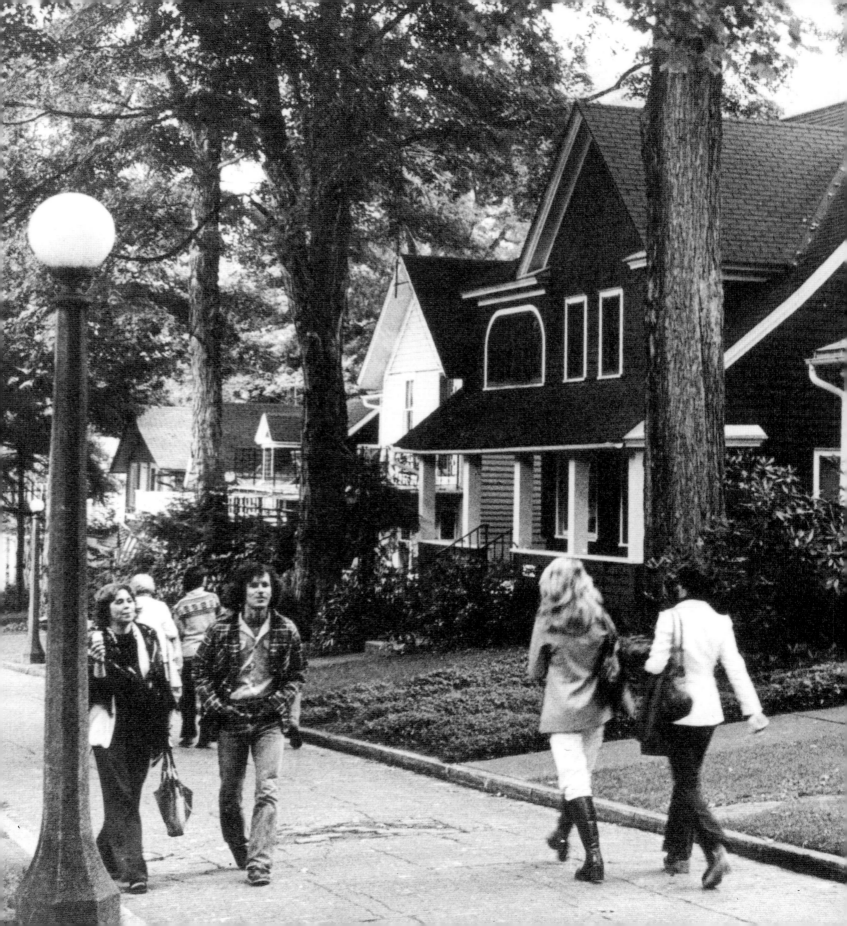

CHAPTER SEVEN

A Shuttered Storehouse

Chautauqua's financial stability, although reestablished in 1936, continued to be a matter of concern for the next thirty-five years. Like someone in middle age who has survived a life-threatening disease, the Institution felt newly vulnerable. The days of youth and confident prime had passed. After the attack on Pearl Harbor on December 7, 1941, for instance, both Bestor and Hazlett were concerned that attendance would be so far down for the 1942 Season, with gas rationing and transient summer visitors focusing on war efforts, that there would be another crisis with gate receipts. This decline did not occur, but it led to a drive for Chautauquans to buy war bonds and donate them to the Institution.

In February 1944, an unexpected tragedy hit the Institution—the sudden death of Arthur Bestor at the age of sixty-four. He had been following his usual punishing schedule of meetings and lectures through the fall and winter and collapsed after returning to his home in New York after a trip. In 1942 Bestor had lectured on the need for Chautauqua to stay vibrant, to provide a forum for the constituency to come to terms with the national crisis. "An institution like ours," he said, "should regard as a

first responsibility in the national effort, the maintenance of our work in full strength and efficiency." With Bestor's death, the program did continue to address the issues of the day, but the control of the Institution tipped toward the money men. The priority for the next thirty years would be maintenance, not innovation.

One strong intelligence keeping up the level of the program was that of Ralph McCallister. Just before his death, Bestor had hired McCallister, who had been director of the Adult Education Council of Chicago, to help him. When Ralph Norton, Chautauqua's longtime bene-

Opposite: In the late 1960s, although Chautauqua again approached a financial crisis, the typical summer resident found just peace and continuity.

Right: Even in its dormant years, Chautauqua's young people have shown vigorous promise for the Institution. One lone clubber stands among a tangle of bicycles at the Boys' and Girls' Club in the 1950s.

Ralph McCallister (left) was program director of The Chautauqua Institution from 1944 to 1961. In a generally conservative time he brought innovative programming such as jazz and ballet and speakers on the United Nations and race relations to the Amphitheater stage. In 1957 Thurgood Marshall, later a justice of the Supreme Court of the United States, at the time legal officer for the NAACP, spoke at Chautauqua.

factor, was named to succeed Bestor as president, he needed a professional to direct the program, so McCallister stepped in during the summer of 1944—and stayed on as director until 1961. He would work, not always smoothly, with the three presidents who succeeded Norton as well—Samuel Hazlett, who moved from the presidency of the Chautauqua Reorganization Corporation to the presidency of the Institution in 1946; the Honorable W. Walter Braham, a retired Pennsylvania judge who served from 1956 to 1960; and William Carothers, who was president from 1960 to 1963.

Alfreda Irwin quotes McCallister in her *Three Taps of the Gavel* as saying that he felt at home at Chautauqua "in the creative tradition stemming from Miller, Vincent . . . Harper . . . and to some extent Bestor and found there an opportunity to serve some of my highest aspirations as a professional leader in continuing and adult education, and as a fosterer of the arts and recreations." McCallister forged a relationship with Syracuse University, which began to offer summer-school courses for college credit in 1954, replacing New York University, which had done so

for the previous thirty years; he brought speakers to the Amphitheater who dealt with such issues as the newly created United Nations and the Korean War; and he was the first to bring New Orleans jazz and a program of ballet to Chautauqua. In the area of race relations in particular, Chautauqua was in the forefront of discussion, with such black speakers as Thurgood Marshall, later a justice of the Supreme Court, who appeared at Chautauqua in 1957 when he was legal officer for the NAACP.

Still, this was the 1950s, when complacency and conservatism were the order of the day, and Chautauqua, in its life on the Grounds, was in an especially conservative mode. One indication of this is that while such black leaders as Marshall and Ralph Bunche, winner of the Nobel Peace Prize, were speaking on the Amphitheater platform, until the mid-1960s Chautauqua maintained a separate rooming house for the African-American help imported from a women's college in North Carolina. The building, where personal domestic servants of summer residents also boarded, was called the Phillis Wheatley Cottage, named with unintentional irony for an eighteenth-century Boston slave who was freed, learned to read, and became a poet. Generally, the appearance of the Grounds in these years became a subtle metaphor for the state of the Institution. Victorian cottages that had been a subtle rainbow of colors when they were new slowly all turned to white. Traditions became entrenched and valued for their own sake, and families boasted of the number of generations they represented at Chautauqua. One joke, told affectionately again and again, was that "Chautauqua is the place where old ladies bring their mothers." "Nothing ever changes," people said at the beginning of another Season, nodding sagely at each other, and then continued, *"And that's the way we like it."*

In this atmosphere, McCallister's socially relevant lecture platform and modestly experimental programming in areas such as jazz and dance were condemned by old

In the 1940s, Chautauquans line up for newspapers in the Book Store.

Chautauquans as "liberal." Such criticism did not slow him down. While McCallister agreed that Chautauqua should be run in a "business-like way," he asserted that it was not "like a business," and he maintained that the quality of the program was the priority. But a board composed largely of businesspeople who were emotionally devoted to a Chautauqua they had nearly lost twenty years before because of "visionary planning" pointed irrefutably to a bottom line.

Historian Morrison quotes George Vincent as writing in 1909 during his Chautauqua presidency that the Institution must "be kept in close and sympathetic connection with the great currents of national life. It must be a center from which the larger and more significant movements may gain strength and intelligent support." But the pervasive influence of television in the fifties and sixties further eroded Chautauqua's function as a national podium, as the radio and the movies had done in the twenties.

Morrison points out, as an indication of how far Chautauqua had come from being perceived as a "center," that invitations to speak were declined through the 1950s and '60s. Asked to come to a platform that had hosted both Roosevelts, five other U.S. presidents, leaders of finance, diplomacy, women's rights, and journalism, in this period General MacArthur, Adlai Stevenson, President Eisenhower, President Kennedy, and Richard Nixon (both as vice president and presidential candidate) all turned Chautauqua down.

Aside from Ralph McCallister's programming, the administration's interests during the Hazlett, Braham, and Carothers presidencies tended not to relate to current affairs and to be intramural when they weren't financial. Walter Braham's daughter, Isabel Braham Pedersen, remembers that her father was an early conservationist who worried about the aging of the trees on the Grounds—a concern that, too long put aside, would come back to

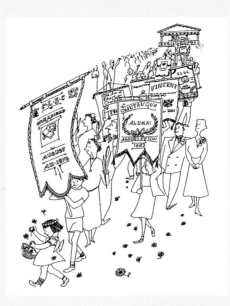

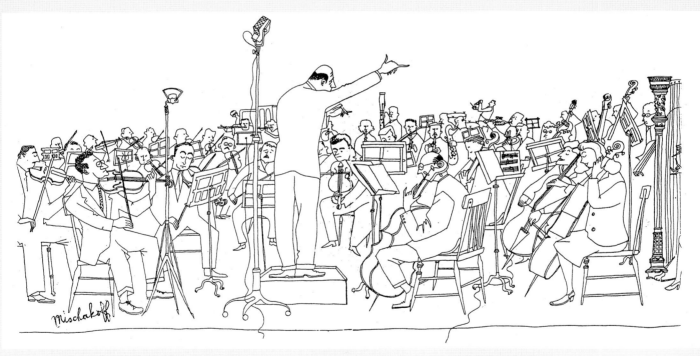

In 1949 Chautauqua's seventy-fifth anniversary was marked by the publication of a short history and guidebook written by Chautauqua author Rebecca Richmond. Artist June Kirkpatrick drew these spicy caricatures of life on the Grounds, most of it still recognizable today.

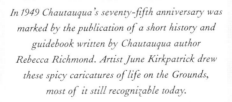

The Chautauqua Literary and Scientific Circle graduating class of 1950 suggests
how the Institution's constituency—and particularly the CLSC membership—aged
and became more insular during the post–World War II years, but the character and
determination of those who, as Bishop Vincent had written, "hope and resolve
to go on and on and up and up and 'higher yet'" are still clear.

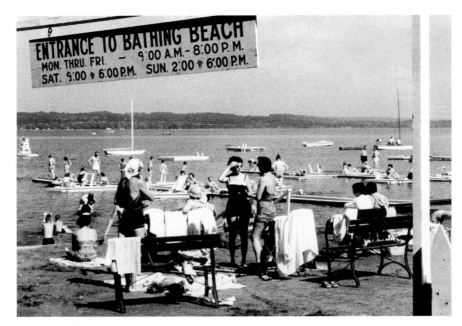

The resort aspect of Chautauqua has always been a strong element of its summer program,
and this view of the South Bathing Beach (later Heinz Beach) from the 1950s
shows a time when play was a priority for many Chautauquans.

Bowling on the green and golfing on the course across from the Institution Grounds in the 1950s.
Behind the golfers is the Main Gate building, the entrance to the Grounds.

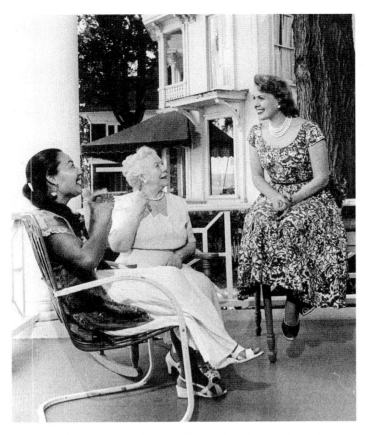

*Madame Shao Fang Sheng, a Chinese artist, relaxes on the porch
of the Chautauqua Women's Club, where she was a speaker in the 1950s.
Madame Shao has continued to be a Chautauqua summer resident
to this day.*

*Marian Anderson, who was offered a platform at the Lincoln Memorial
by Eleanor Roosevelt in the 1930s after being refused the stage of the Daughters
of the American Revolution hall because she was black, sang at Chautauqua
several times. She performed at the Amphitheater during her national
farewell tour in the 1960s.*

haunt the Institution in the 1990s. "But mostly," says Pedersen, "Dad just worried about where the money was going to come from." Alfreda Irwin points out that Samuel Hazlett felt that the programs sponsored by the Department of Religion and the summer-school classes were the most important elements of the Chautauqua mix. He also was particularly interested in the young people who filled the Grounds as children of summer residents and college-student employees. The recreational High School and College Clubs "flourished under his presidency," as well as the day camps for younger children, the Boys' and Girls' Club.

With the departure of Ralph McCallister, who finally broke with the Chautauqua board of trustees over issues of budget, there was a need for a professional program director. Curtis Haug, a former YMCA secretary in nearby Jamestown, had been hired in 1960 to be the Institution treasurer, and almost before he had started in that job he was named to be program director, a position more congenial to his talents and training. William Carothers resigned as president in 1963; and Curtis Haug, after an interim acting presidency of longtime Chautauquan George L. Follansbee, Sr., was named president.

Haug remained as president and program director until 1970. It is useful to glance at the program during these years because a casual visitor would have trouble perceiving that Chautauqua was in a period of inertia. As in the Depression, the cornucopia of summer activities continued to spill forth in a mix uniquely Chautauquan. Walter Hendl stayed on as conductor of the Chautauqua Symphony and succeeded summer Chautauquan Howard Hanson as head of the Eastman School of Music in 1964. In the opera, as well as the expected performances of *Madame Butterfly* and Gilbert and Sullivan works, among the seven productions per Season there was one of Robert Ward's *The Crucibl*e, based on the Arthur Miller play, and one of *The Unicorn in the Garden* by Russell Smith, based on a James Thurber story. From 1955 on, there was a full program of dance classes and recitals in the Amphitheater; and since 1960 there has been a Chautauqua Dance Company. On the lecture platform, just a few of the speakers and topics included Dr. Karl Menninger, the psychiatric physician, discussing capital punishment; Dr. Chun Ming Chang, ambassador of the Republic of China to the United Nations, discussing whether his country or the Communist mainland government would ultimately prevail in the Far East; and Professor George H. Williams of Harvard Divinity School reporting on "The Vatican Council from John XXIII to Paul VI." Gerald Ford and Robert Kennedy gave "Meet the Press" interviews in the Amphitheater on two successive Friday nights. African-American diva Marian Anderson made Chautauqua a stop on her farewell tour; she had been a mythic American figure since the 1930s, when Eleanor Roosevelt asked her to perform at the Lincoln Memorial after she was turned away from a Daughters of the American Revolution hall in Washington because she was black. At the height of their popularity, the Kingston Trio filled the Amphitheater, and the Mormon Tabernacle Choir drew standing-room-only crowds twice in one day.

It is fascinating to compare the extraordinary range of the program with the increasingly insular interests and shrinking size of the constituency. Essentially, an extremely elaborate program with gate receipts that covered only one-third to one-half its expenses was being maintained by a community with a core group of six to eight thousand people. Although Chautauqua has always been unreservedly open to anyone who could buy a gate ticket, functionally it was as though a private summer club kept for its own pleasure a full symphony, an opera company, a theater company, a dance company, and a lecture platform, as well as the more-predictable golf course and marina.

There is a cliché in the world of not-for-profit organizations that says that after three generations, institutions tend to exist for their own perpetuation, rather than for the purposes for which they were founded. By the end of the 1960s, Chautauqua had slipped dangerously close to this state of affairs. The board of trustees, for instance, discouraged the administration from advertising the program in national newspapers because they feared the crowds advertising might attract. The very fiscal and social conservatism of its leaders, which they had hoped would save Chautauqua for themselves and their families, ironically led to financial peril. The alternatives of television and other arts festivals proliferating around the country made the Institution less and less compelling, and there simply were not enough old Chautauquans to keep things going. Philosophically, the situation was even more deadly: from being "the city set upon a hill to shed a light unto the world" and Bishop Vincent's manna for the "hunger of mind abroad in the land," Chautauqua had turned into a shuttered storehouse, decaying around the ephemeral riches it tried to hoard.

Sunfish sails drying in front of lakeside cottages in the late 1960s.

It's never too early to start fund-raising for Chautauqua.

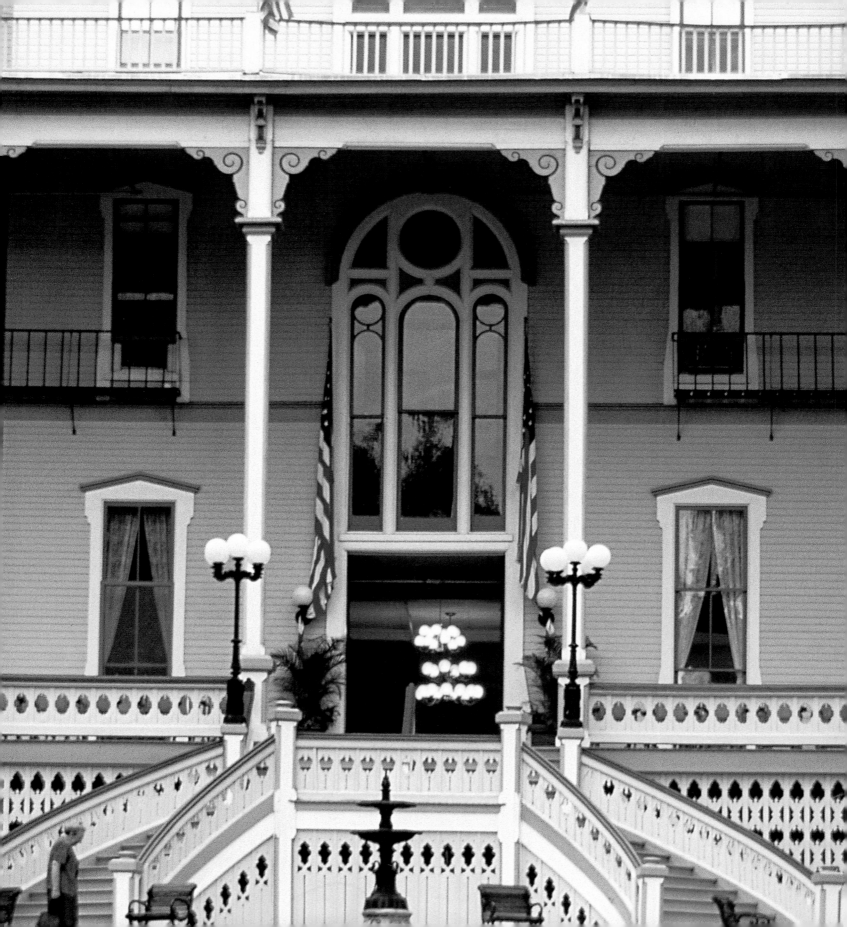

Rebirth

In September 1970, Curtis Haug resigned as president of Chautauqua to become director of a performing arts center in Sarasota, Florida. Shortly before that, Richard H. Miller, a Milwaukee lawyer and great-grandson of Chautauqua cofounder Lewis Miller, had been elected to the Chautauqua board of trustees, and he was made chairman of the search committee for a new president. Two months later, he was also made chairman of the board of trustees.

At this point, Chautauqua, once again, was almost broke. There were the gate ticket receipts, to be sure, but the Annual Fund contributions, which were provided to the Institution almost entirely in small amounts by summer Chautauquans, were an inadequate supplement to ticket sales. This meant that a pattern had been established of borrowing money for basic operating expenses through the winter, from October, when the summer's earnings were depleted, to May, when early ticket purchase money began to come in. Although there was an endowment fund, administered by the Chautauqua Foundation, which had been established after the Depression and added to over the years, it totaled only a little more than $1.5 million and brought in a very low annual return in interest.

Opposite: The Athenaeum Hotel, completed in 1881, was renovated in 1982, when this imposing central stairway was added.

By the early 1970s, the Institution was more than $600,000 in debt.

Money problems aside, Miller felt that it was essential to find a president who could give Chautauqua a sense of serious purpose for the future, beyond ad hoc entertainment and established and easy precedents. The man the search committee found was Oscar Remick, a young Baptist clergyman who had been academic dean in a Roman Catholic college in Massachusetts. In an epilogue to Theodore Morrison's *Chautauqua*, Remick wrote: "Chautauqua, once characterized as typically American, will find its future by representing what is ideally human. This means that the narrowed identification of Chautauqua with a certain segment of our society must give way to an openness, a universality. . . . The temptation to become a traditional educational institution must be shunned. The appeal to develop at the expense of all else a center for one or all of the performing arts must be rejected. Efforts to make it only an institution for religion must not be allowed. . . . As an institution designed to encourage meaningful living, Chautauqua is all of these or nothing."

As a statement of purpose, Remick's statement addresses directly Chautauqua's dilemmas and sets essential goals. Nothing, however, would be possible without money. A professional fund raiser who was hired as a con-

sultant made it clear to Miller and Remick that in order to interest a philanthropic foundation they would have to establish three concepts: what the appeal of the Institution was to a broad constituency; who believed in it already; and where it was going.

In 1972, the first full year of Oscar Remick's presidency, the Institution operated at the largest deficit yet. This was only two years before the centennial summer, and Remick, a visionary and a man of great personal charisma, set out in conjunction with Miller to heighten the image of Chautauqua in the world at large and enliven its own devoted constituency. Miriam Reading, a lifelong Chautauquan, was made chairman of the volunteer Centennial Central Committee, and a focused program of publicity abroad and action at home, using the centennial as a justification, was initiated.

Application was made to the Post Office Department in Washington for a commemorative stamp to be issued during the centennial summer. Ultimately, a stamp appeared, but it pictured an old tent show from the traveling Chautauquas and honored the entire Chautauqua Movement; it is a policy of the Citizens' Advisory Stamp Committee, which selects subjects for stamps, not to focus on specific institutions or municipalities. Nonetheless there was the name "Chautauqua" unavoidably visible on a national scale for the first time in decades. The First Day of Issue stamps came out of the Chautauqua post office with an appropriate ceremony, and Dr. Remick appeared on the "Today Show" the morning before the stamp was issued.

In 1973 the Chautauqua Grounds were officially added to the National Register of Historic Places. In May of the centennial year The Chautauqua Institution received an award for a distinguished contribution to the arts from the New York State Council on the Arts, an organization of which Dr. Remick would become a member during his presidency. All of these actions indicated a

willingness to engage the world and a sophistication about how that should be done that had long been absent from the Institution's thinking.

At home on the Grounds, Richard Miller, as chairman of the board of trustees, asked individual trustees to introduce the morning lecturers on the Amphitheater platform to indicate the board members' visible, active commitment to the workings of the Institution. He himself took a leave of absence from his law firm during the summer of 1971 and made himself available four afternoons a week in half-hour increments to anyone who asked to see him about Chautauqua, present or future. Chautauquans poured in with ideas, ranging from the volunteer director of the Chautauqua Art Gallery proposing that a centennial art show solicit nationwide entries, to a retired engineer explaining that Chautauqua's first bus, providing transportation for pedestrians around the Grounds, was a good idea but the wrong size for the narrow angles of Chautauqua lanes.

The Centennial Central Committee established many subcommittees, some of long duration, such as one on the environment, which opened Chautauquans to the idea of considering the future of the place as well as celebrating its past. It allowed them to participate in planning in a way they were obviously hungry to do.

The actual program for the centennial summer was impressive in its innovations. In addition to the usual substantial offerings of symphony, theater, lectures, summer-school classes, and recreation, there was the world premiere of an opera, *Philip Marshall*, with libretto and music by American composer Seymour Barab, sponsored by the New York State Council on the Arts and reviewed at Chautauqua by Allen Hughes of *The New York Times* and Robert Cumming of *Music Journal*. Longtime Chautauquan and internationally renowned composer Howard Hanson conducted his own opera, *Merry Mount*, later in the Season. A morning lecture series called "The

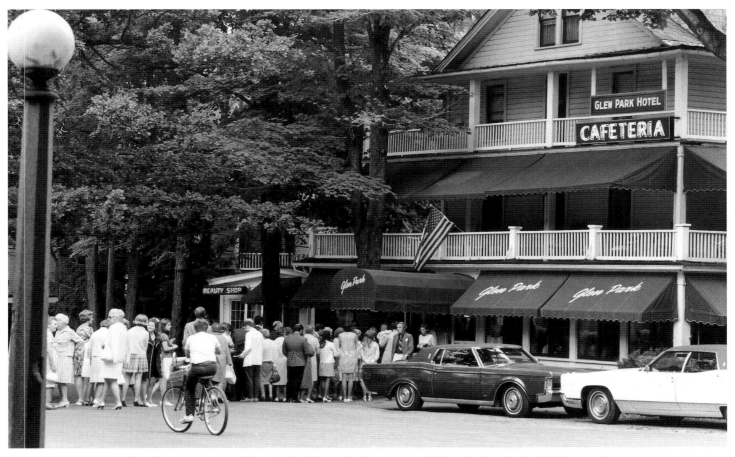

The Chautauqua summer residents who lived in rooming houses ate wonderful meals of meatloaf and chicken pot pie,
fresh tomatoes and corn on the cob, and desserts like raspberry shortcake for as little as a dollar or two at the many cafeterias and hotels
around the Grounds. Here is the popular Glen Park Cafeteria in the early 1970s, with a crowd waiting
after the Sunday Amphitheater church service.

Coming of Age: A Celebration," was arranged, which featured Edward Weeks, senior editor of The Atlantic Monthly Press; Dr. Karl Menninger of the Menninger Foundation; Maggie Kuhn, national convener of the Gray Panthers; and Roy Wilkins, executive director of the NAACP. On the more recreational side, there was—for the first time at Chautauqua, with its nondrinking, nondancing heritage—a ball in the parlor of the Athenaeum Hotel, with a dance orchestra led by Peter Duchin.

The festivities of the centennial summer offered a ray of hope for the administrators and trustees who were struggling to keep Chautauqua from disappearing into the darkness of financial chaos. But the paradox of the program being so vigorous despite Chautauqua's money troubles went hand in hand with the serenity of life on the Grounds for most summer residents at the time. As lifelong Chautauquan and *Time* Senior Writer Nancy Gibbs notes, the sun merely shone especially brightly that year on what seemed to be an unchanging idyll. "Speaking as a teenager in the seventies, as long as the Bestor Fountain [sculpted] fish still spit, as long as the library still had books, as long as you could still go off from Girls' Club

A young Chautauquan follows a time-honored Chautauqua custom of playing with the fishes at the fountain on Bestor Plaza, named in honor of Arthur E. Bestor, Chautauqua's president from 1915 to 1944.

and take piano lessons, for me and my cohorts, if the place was in financial trouble we didn't notice," she says.

While the centennial program of events and publicity was unfolding, Miller and Remick were busy cultivating financial resources. They persuaded the Gebbie Foundation of nearby Jamestown, New York, to award The Chautauqua Institution a $1 million challenge grant, which would be available in $200,000 increments over five years, if Chautauqua raised at least $600,000 each year in private donations and paid off all major debt during the same time.

A professional development officer was hired, the first of a number of full-time senior staff positions created for professional direction of the Institution's areas of operation. Under the previous administration, the only full-time administrative positions had been president/ program director and treasurer.

Another concern, if Chautauqua was to continue into the twenty-first century (or even, as it sometimes seemed, into the next Season), was the serious attention that had to be paid to its buildings. The unique collection of twelve hundred privately owned Victorian cottages were usually

adequately maintained by their owners. The public buildings owned by the Institution, however, from the cavernous Amphitheater and the grand Athenaeum Hotel to the elegant Hall of Philosophy to the little brown-shingle huts, each holding a single piano, where the music students practiced, were in a state approaching collapse. Although they had been kept looking decent over the years, there had been no money to pay for structural maintenance. At the end of one Season in the 1970s, the Amphitheater's insurers informed the Institution that they could not renew the policy for the next Season unless essential steps were taken to keep the 1.3-acre roof from slipping off its support posts and crashing down onto the five thousand people who might be seated below. Money was taken from an emergency reserve fund with the Gebbie Foundation's permission, and the crisis was averted.

In December 1976, Oscar Remick announced his resignation as president to accept a position as dean of performing arts at Fredonia College of the State University of New York. Under his administration, the Gebbie Challenge had been taken on and been successfully met in its first two years; the organization of the administration had been expanded and put on a professional level; Chautauqua had regained national visibility for the first time in thirty-five years; and generally Chautauquans had turned from a fond but unproductive reliance on the past to realizing that they had a future.

A search committee was formed to find a new president, and the last issue of *The Chautauquan Daily* for the 1977 Season announced the appointment of Dr. Robert Hesse, who had most recently been president of Medaille College, a small liberal-arts institution in Buffalo. Hesse was trained as a professional educator, a background that had proven to work well for previous Chautauqua leaders, from George Vincent to Arthur Bestor to Ralph McCallister to Oscar Remick. He was also a trained musician and a public relations expert who had been a guiding spirit in the Committee for the Revitalization of Buffalo. Although inner-city problems were very different from those of a cultural institution and resort, addressing the need for a multifaceted community to move into the future rather than relying on patterns from the past would be a useful way of focusing Chautauqua's rediscovered energy.

Dr. Hesse announced that he would take a year, through the Season of 1978, to "listen and learn," to steep himself in what Chautauqua was about. The 1977 program had been the usual buoyant potpourri, with platform personalities ranging from Ethel Merman to Margaret Mead, who returned the next year as the CLSC graduation day speaker. In fact, the 1978 CLSC class—which celebrated the one-hundredth anniversary of the CLSC—was named for Mead. Though the organization had diminished to an intramural reading club, it was a glorious one—in 1978 John Ciardi, poet and translator of Dante,

Margaret Mead spoke at Chautauqua in 1977, and she was the CLSC graduation day speaker in 1978.

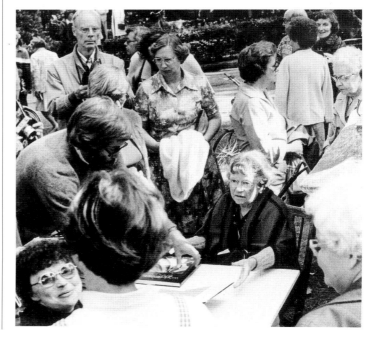

offered a course on the *Divine Comedy,* and James McPherson, winner of that year's Pulitzer Prize for Fiction, spoke at a CLSC lecture, as well as Mead. In its tenacity, the CLSC was a brave metaphor for some of the Institution's struggles with its own place in the world. This year was also the fiftieth anniversary of both the Chautauqua Symphony Orchestra and the Chautauqua Opera. In its twenty-one concerts, the symphony included soloists such as Yo-Yo Ma and Peter Martins, dancing to the orchestra's music; and the opera invited former members of the company to attend a gala performance. Thirteen symphony concerts were taped for winter broadcast on public radio stations in Pittsburgh and Erie.

In 1978 Richard Miller felt that the turning-around of Chautauqua that he had initiated with Oscar Remick was well under way. The Gebbie Challenge was being met with Chautauqua fund-raising, and there were plans for further professional development programs. The composition of the board of trustees had slowly been transformed from a group of elderly—albeit devoted— Chautauquans to a group in the prime of life with philanthropic experience who were actively engaged in business and the arts. In Miller's view, the Institution was on the road to a sound financial status, and he felt that he had accomplished what he had set out to do. Consequently, Miller resigned as chairman of the board of trustees, though he kept the potent position of chairman of the Chautauqua Foundation and remained on the board as a trustee.

The new chairman was Howard Gibbs, associate national director of the Boys Clubs of America and a Chautauqua trustee of ten years. Over the time of his chairmanship, Gibbs would contribute significantly to the Institution's thinking in terms of the need for formal, long-range planning. With his initiation of open forums in which all Chautauquans could participate, airing grievances and asking questions, Gibbs made a populist statement that helped the everyday Chautauquan not to feel disenfranchised.

At the end of the 1978 Season, President Hesse presented a report to the trustees, in which he asked questions that had come out of deliberations of the program committee, one of the board committees composed of trustees and community members. In a statement that recalls Oscar Remick's remarks about Chautauqua needing to be a balanced mix of its parts or it was nothing, Hesse asked, according to Alfreda Irwin, "Should we continue to have a symphony orchestra and if so, should it be ours? Should we have a theater program? If so, should it be the Cleveland Playhouse? How long should the Season last? . . . How can we generate more support for what we do and who we are?" The president concluded that Chautauqua was in a condition of "less than excellence" and that the program lacked coordination.

These remarks were a tacit recognition of a condition that tends to come about in an institution with a weakened central authority where subgroups begin to function autonomously. Although Chautauqua had recovered much of its strength in the years 1971 to 1978, the immediate need for administrative reform and money had allowed the orchestra, the Cleveland Playhouse, the opera, and to a lesser degree the CLSC and the Women's Club to plot their own courses virtually independently of Institution control. Independent programs sometimes conflicted with Institution programming, fund-raising by specific organizations diverted funds, and the orchestra union demands became increasingly assertive.

Dr. Hesse took some control of the music program when he appointed a new music director in September 1980, in the person of Varujan Kojian, who had been director of the Utah Symphony and principal guest conductor of the Royal Swedish Opera. Emanuel Ax, Ruth Laredo, John Browning, and Jean-Pierre Rampal were among the guest artists for the symphony for the 1980

A performance of Tom Stoppard's The Real Thing *by the Chautauqua Conservatory Theater.*

A young family, typical of Chautauqua's current constituency, rests on the porch of a cottage from the Institution's first days.

Season; they were chosen by Dr. Hesse and announced by him at an unprecedented April press conference in New York. After long negotiations, a new contract with the orchestra was signed in January 1981.

The Cleveland Playhouse presented *The Importance of Being Earnest* in 1979, its fiftieth season at Chautauqua; that was the first play it performed on the Grounds in 1930. This pretty act of homage was offset in the minds of many Chautauquans by the fact that for many years the theater had had decreasing attendance and had to be subsidized. When the cost for the 1981 season was projected at over $200,000, with projected income at $122,000, the board voted to eliminate the Playhouse from the budget.

Instead, in 1982, the Acting Company, a touring arm of the Kennedy Center in Washington under the direction of John Houseman, brought three productions to Chautauqua, *The Country Wife*, *Twelfth Night*, and *Tartuffe*. The company returned in 1983. After that, well-known theater director and educator Michael Kahn created a Conservatory Theater Company and Theater School for the Institution, which has continued well into the 1990s under the directorship of Rebecca Guy. The theater school has gained national recognition as a training program, and in addition to its own productions, it presents two guest-artist productions each summer. The decision to produce its own theater was part of Chautauqua's conscious movement toward centralized control of all aspects of its program, regardless of any specific problems with subsidies and choice of plays on the part of the Cleveland Playhouse.

It is necessary to note that the ultimately successful efforts to centralize control made the Hesse years at Chautauqua frequently contentious. There were strong partisan feelings on the Grounds, particularly regarding the difficult negotiations with the orchestra, which had—and cultivated—its own adherents. At times it seemed as though there were hard feelings relating to everything from program issues to an attempt to change the way garbage was being collected. In fact, this was the painful knitting of bones of an organization coming back together again after decades.

There are two developments of the Hesse years, both relating to real estate, that indicate the renewed determination of the Institution to move ahead and reflect the energy of that course. One major effort was the Second Century Campaign, undertaken in 1979, for improvements to—indeed, the salvation of—the Institution's major buildings as well as program support. It ultimately brought in $8.5 million over five years. Among the buildings that were renovated were the Amphitheater ($2.5 million); the Hall of Philosophy, which was the jewel of the turn-of-the-century City Beautiful movement at Chautauqua; and the Arts and Crafts Quadrangle, a three-sided square of distinguished Shingle-Style buildings in the North End of the Grounds. In addition to the Gebbie Foundation, which contributed to this campaign following the successful termination of its earlier grant, the Institution for the first time availed itself of appropriate federal funds from the National Endowments for the Arts and for the Humanities and from the National Historic Trust. In what had traditionally been a fiscally conservative institution, with a deep-seated Republican distrust of "government interference," this was a real statement of the intent to position itself in the nonprofit arts world of the late twentieth century.

Starting in the mid-1970s, some vacant lots in the generally crowded central section of the Grounds were sold by the Institution for private development. A series of townhouse condominiums was built on Ames Avenue, one of the main streets leading from the Entrance Gate to Bestor Plaza, the town green; and another row was erected near the tennis courts. Then, in 1982, thirty units of time-share condominiums were built on Elm Lane in the far north end of the Grounds on undeveloped property.

Soon thereafter a wooded area in that part of the Grounds was opened to development, with new streets named Hazlett and Gebbie, after Chautauqua's financial saviors. More condominiums were built in this area, and several streets' worth of substantial private houses were constructed as well; while they were used principally during the Chautauqua Season, they are appropriate for year-round habitation as weekend retreats for owners from Cleveland and Pittsburgh.

At the same time, many of the old rooming houses in the center of the Grounds were being sold, often at high prices, by families who had owned them for generations. These were often renovated into condominium apartments by the new owners. The sale of Institution lots, of course, put money into Institution coffers, but the transformation of old houses into modern apartment spaces tended to do so indirectly as well. The Chautauqua constituency—traditionally composed of a relatively few rich families (often bearing legendary American names: Heinz, Studebaker, Edison), many more prosperous middle-class families with small-town roots (perhaps including a banker from Titusville, Pennsylvania, or a doctor from Sandusky, Ohio), and a lot of visiting schoolteachers and Protestant ministers—was changing. Younger families with more money than the teachers and preachers were finding that the new housing provided an attractive way for them to be able to enjoy the tremendous riches of Chautauqua. As more new or renovated housing became available, more people wanted it, and property values rose accordingly. These "new people" had more money to contribute to Chautauqua, both in accepting higher gate fees and in responding to solicitations. As new as they were, though, this revitalized constituency grew out of the old in many cases: A study done in the early 1990s showed that more than 80 percent of the time-share residents of the condominiums in the north end had some previous family connection to Chautauqua or had first come there with friends a number of years earlier.

With new money came new blood—both transfusions essential to an aging, ailing Institution. But change is, by its nature, not without a negative side. Families who had rented rooms at Chautauqua, sometimes for generations, felt that they were just as much a part of the community as families who owned property; and many had loyally supported the Institution with such contributions as they could make through its darkest days. Some of these people now felt edged out. Summer-school faculty and symphony and opera performers who were too old for student housing also began to have trouble finding accommodations on the Grounds. This diluted the domestic mix of performers and audience that makes so rich a community.

In addition, Chautauqua came close to losing much of its invaluable, unique townscape, one that reflected the building styles and planning aspirations of the previous 125 years. The enthusiasm for the new began literally to wipe away the old until an architectural review board was established, and preservation guidelines were put in place.

Without these and the other changes of the years 1970 to 1983, there would be no Chautauqua for anyone to enjoy—it would be nothing *but* a collection of buildings. While the problems created by change are very real, in an institution commanding the loyalty of its adherents to the degree Chautauqua does, the negative effects of change will usually be checked before they are irreparable. To a significant degree, the "new" at Chautauqua could be seen to be the healthy strength of a new generation descended from the old.

In October 1983, when Dr. Hesse announced that he was leaving to become executive director of the foundation of the Joffrey Ballet, because of the strength of his administration and the initiatives of his predecessors, and because of the continued efforts of countless Chautauquans, the Institution was, finally, on good financial footing.

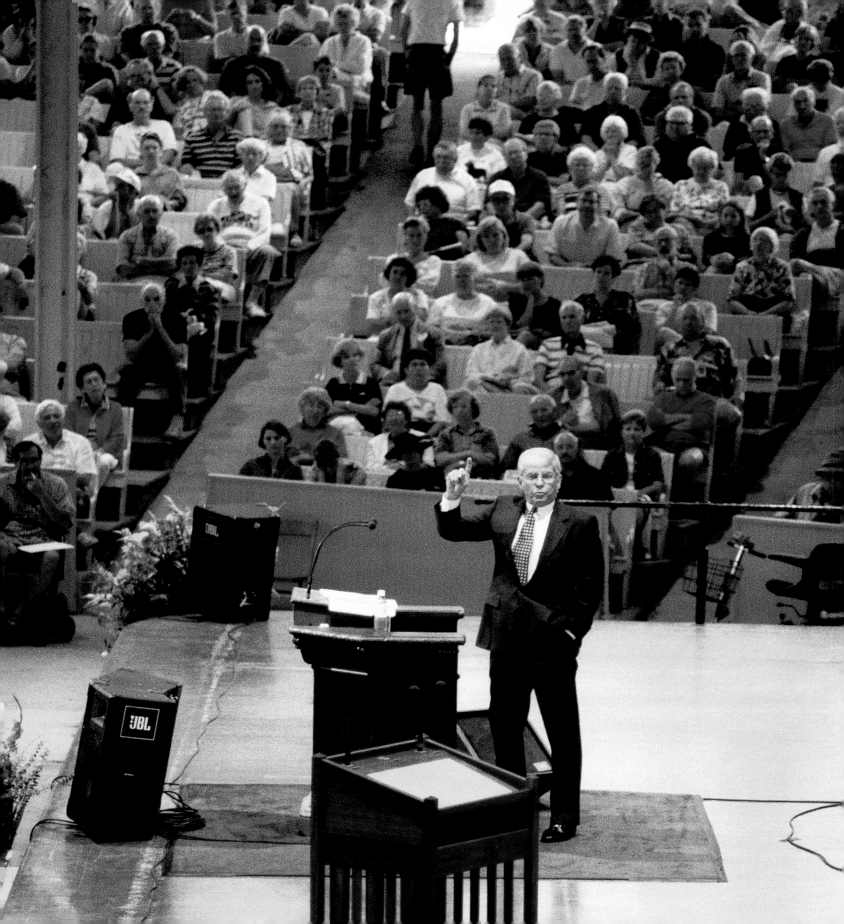

Glory Days

Daniel Bratton, an ordained Methodist minister who had been president of Kansas Wesleyan College for ten years and before that an administrator of the University of Maryland, became president of Chautauqua in 1984. "When I came here it was evident that the Institution was not in a state of crisis," he says. "There was no need for immediate surgery."

"Of course," Bratton continues, "there had to be some vision for the future, and for me that lay in fostering a greater sense of community." Bratton refers both to the constituency and to the professional community with this remark. His relationship with members of the orchestra and other constituents of the Institution has indeed been cordial, as has his relationship with the strong—and strongly cohesive—senior staff he began to build soon after his arrival. Bratton has had the third longest tenure—after Lewis Miller and Arthur Bestor—of any Chautauqua president, and his emotional connection with the place on behalf of his family and himself has been intense. The groundwork laid in the preceding decade and a half served as the basis for the tremendous growth that has ensued under his administration.

In 1985—Bratton's first full season at Chautauqua—an event took place that would broaden the Institution's horizons in a way that nothing had since FDR said "I hate war" in 1936. John Wallach, foreign affairs editor for Hearst Newspapers, who had organized lectures on international affairs at Chautauqua, had the idea that Chautauqua would be the perfect setting for a conference on U.S.-Soviet relations, the kind of program in which Mikhail Gorbachev's Russia, bent on perestroika and glasnost, was eager to engage. Bratton and Wallach made a trip to Moscow to confirm details in April 1985, and the conference was set for June at Chautauqua, the first week of the Season.

The conference was attended by about a dozen Soviets, temporarily or permanently attached to the embassy in Washington. It was a successful diplomatic exchange of views between such speakers as Paul Nitze, senior advisor to President Reagan on nuclear armament and arms control, and Viktor Malkov, professor of history and member of the Academy of Sciences, USSR. The conference received attention in the media; but also importantly for Chautauqua, it and following conferences would prove to corporate and nationally based donors

Opposite: Presidential hopeful Jack Kemp speaks at Chautauqua in the summer of 1996.

that the Institution, with major programs, was a major contender for their money. The Pepsi-Cola Corporation helped defray the conference expenses, and the New York State Public Television Stations helped to fund a documentary on the week.

The most important consequence of the week, however, was what it led to. The next year, on Wednesday, September 10, after the close of the 1986 Season, approximately 250 Chautauquans, including Institution administrators, traveled to Washington. There they met such American government officials as Jack Matlock, Senior Advisor to President Reagan on Soviet Affairs, and Mark Palmer, Deputy Secretary for Soviet Affairs in the State Department and ambassador designate to Hungary; journalists including Strobe Talbott, *Time* magazine's Washington bureau chief; and performers including singer Karen Akers, jazz saxophonist Grover Washington, Jr., and dancers Patrick Bissell and Susan Jaffe. The group was heading for a conference that would take place with Soviet counterparts to our government officials and performers, as well as Soviet citizens. The location was to be an old resort called Jurmala on the Baltic near Riga, the capital of Latvia. Chautauqua, of course, is a community largely composed of Victorian cottages surrounding an open-air amphitheater by a lake; Jurmala was a community of Victorian-era houses with an open-air meeting hall on the shore of the Baltic. The mirror image of place was a metaphor for the mirror image of megapowers.

Spearheaded again by John Wallach and cosponsored by the Eisenhower Institute, which was headed by the president's granddaughter Susan Eisenhower, the conference was endorsed by the United States government (although the official agreement was between the Soviet government and The Chautauqua Institution) and eagerly sought by the glasnost-bent Russians. There were many complicated snags both before and during the trip, one of which almost stopped it altogether at the last minute: An American journalist for *U.S. News and World Report* named Nicholas Daniloff had been arrested in Moscow at the end of August, after accepting some documents from a Russian. This occurred shortly after a Russian named Gennadi Zakharov, who was attached to the United Nations in New York, was arrested by the Americans for spying. The U.S. government called Daniloff's arrest mere retaliation, and while 250 Chautauquans cooled their heels in Washington, the government said that the State Department speakers for the conference would not attend unless Daniloff was released. The trip was delayed for three days, and Robert MacFarlane, former White House national security advisor, and Jeane Kirkpatrick, head of the American delegation to the United Nations, dropped out. Daniloff was, however, released to the American Embassy in Moscow—an indication of the eagerness of the Soviets to have the conference proceed.

The issues discussed at Jurmala were arms control, regional tensions, and the role of the press, with an eye toward determining relations between the two countries. The first day's session—as noted by *The New York Times*, which covered the "town meeting" for four straight days, September 15–18—was contentious. The Americans refused to let the issue of Daniloff drop; Jack Matlock said the arrest had been "the seizure of a hostage [until Zakharov's fate was determined]." The *Times* made the assessment that "in open debate American and Soviet participants traded accusations of repression and discrimination, lack of sincerity in arms negotiations, hypocrisy in human rights and disregard for national sovereignty." The next day, the *Times* pointed out that "the conference format is a startling departure from Soviet routine," and quoted a State Department official who said, "We are getting a better chance to talk here, and to get to know one another than on almost any occasion I can recall." On September 21, summing up with a fifth day's coverage, the *Times* said, "American diplomats attending a Soviet-

American conference here this week said they could not recall another occasion when such a sustained critique of Soviet policies was approved for domestic consumption" and opined that it was a sign of expanding opportunities for Soviet citizens.

In terms of human interaction, the conference was successful, if somewhat sprawling, with 250 determinedly independent Chautauquans, guidebooks in hand and the sense of being free citizens firmly in mind, encountering the citizens and cityscapes of Soviet life in Riga and Moscow. "Your people, they do not do what they are told," said one Intourist official heavily to Bratton.

For the Institution, the conference was obviously a triumph in that it made Chautauqua, almost fifty years to the month after FDR's visit, once again a player on the national—and even international—stage.

In 1987 approximately two hundred Soviets, including an official delegation that *The New York Times* called "a Who's Who of Mikhail S. Gorbachev's 'glasnost' campaign," came to Chautauqua for a week on the Grounds. New York Governor Mario Cuomo's keynote speech was on the *Times* front page. Among the group were 170 Soviet citizens—lawyers, journalists, professors, scientists, and ordinary folk such as a thirty-nine-year-old telephone operator who spoke no English. After being welcomed with a marching band, balloons, and signs that declared "Welcome Brother" in Russian, the Soviets stayed in the homes of Chautauquans. The *Times* said, "If world peace is not declared by the end of the week, it will not be for lack of trying by the people of Chautauqua." This brought the heady winds of an international encounter to all the Chautauqua constituency. In 1988 there was a further exchange, to Tbilisi, Georgia, and in 1989 one final conference was held, under Chautauqua sponsorship, at the University of Pittsburgh.

The sense of Chautauqua as being a worthy forum for national issues would continue through the 1990s, with Bill and Hillary Clinton and Al and Tipper Gore spending a Sunday on the Grounds during their bus-stop campaign in August 1992. All four spoke from a platform erected in front of the Library, and approximately ten thousand people filled Bestor Plaza to listen. In October 1996, the White House called at the end of one week, asking if the president, the first lady, and his debate team could come the next week to rehearse for his campaign television encounter with Bob Dole, who had been a speaker on the Grounds the summer before. The closed Athenaeum Hotel was reopened; miles of telephone lines were brought in, along with more miles of electrical cables for stoves in the unheated rooms; and the president and an entourage of four hundred arrived. "Roosevelt came with two state troopers," groused an old Chautauquan.

The point was made, with a picture on the front page of *The New York Times* of the sweatered President strolling on the Athenaeum lawn, that Chautauqua was again a logical nest for power—what went on there mattered. The President's choosing the off-Season for a (very relative) degree of privacy was also a subtle reminder of Chautauqua's retreat aspect. This is a place where things that matter in the world are spawned and discussed, but this is also a place to contemplate those issues and gather one's forces for the world beyond the fence.

As far as the Institution's own plans for its future, the 1990s were characterized by two successive sophisticated strategic plans with supporting fund-raising campaigns, which specifically addressed support for the tremendously varied program. "The Design for the Decade," which was undertaken from 1991 to 1995, netted $24.1 million for the Institution; and "Chautauqua 2000" is projected to bring in almost $30 million.

Today, Chautauqua continues its varied programming, both on the platform and in the organizations it shelters. While affirming its allegiance to its Christian heritage in the Chautauqua Challenge, the Institution has

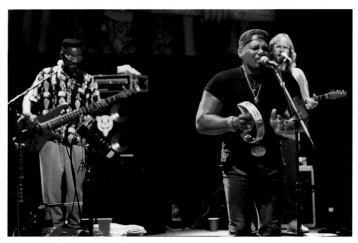

The Neville Brothers perform in the Amphitheater for one of the Friday night popular-music concerts.

employed a rabbi for regular Jewish services on the Grounds for decades. The lectures sponsored by the Department of Religion include scholars of all faiths. Groups as diverse as Parents and Friends of Lesbians and Gays (PFLAG) and Chautauquans for a Christian Focus advertise their meetings, held in Institution buildings, in *The Chautauquan Daily*.

Recent speakers have included Freeman Dyson, professor of physics at the Institute for Advanced Studies, who spoke during the week of lectures organized around the theme of "The Promise and Threat of Biotechnology"; and Arthur Levine, president of Teachers College at Columbia University, participated in the lecture series called "The Road to Educational Excellence." Musicians recently on the program have included Mary Chapin Carpenter and Wynton Marsalis. The ballet school, under the direction of Jean-Pierre Bonnefoux, is nationally known, while the opera, under the lively direction of Jay Lesenger, staged a riveting production of Donizetti's rarely performed bel-canto work *Maria Stuarta*, as well as the more predictable *Madame Butterfly* and *Carmen*.

Chautauqua's place among summer festivals is unique. It has no peer. Other formidable festivals—Tanglewood, Saratoga, Aspen, Santa Fe—do of course exist, but none embraces all the arts and offers the sense of community for which Chautauqua had been known for 125 years. David McCullough said in 1993, "There's no other place like it. When you're here you know exactly where you are. . . . When you are present here with the past, you are present with a body of ideology with a volume of thoughtful, considered attention to the nature of the American experience. You can draw from it. You need to draw from it."

The unique strength of the place is informed, perhaps, by a sense of posterity which McCullough, in the same speech, attributed to the founders as "the bedrock [that gave] a sense of unifying mission." From the larger picture—in which Chautauqua has again become a site for political position statements and the restored Grounds a model for planned communities across the nation—to the simple fact of the personal continuum of the generations, Chautauqua draws on the past for the sake of the future.

Apropos of the continuum of generations, *Time* writer Nancy Gibbs observes, "Nobody ever thinks of children in connection with Tanglewood; nobody ever thinks of adults in connection with DisneyWorld. Chautauqua is for everyone. At Chautauqua my three-year-old is fed, and I am fed."

"Chautauqua is special," agrees United States Supreme Court Justice Sandra Day O'Connor, who has spoken at and vacationed at Chautauqua with her family. "It is a quiet, lovely retreat from my daily life. It is a world in itself—a good world where beauty and reason come together, where music is heard, where everyone, whether eight or eighty, has some interesting activity all day each day."

In short, in 1999, as in 1899—and 1874—it is still Chautauqua's genius, as Bishop Vincent wrote all those years ago, to allow that "every man has the right to be all that he can be."

An evening performance by the Harlem Spirit Ensemble in the Amphitheater.

Doris Kearns Goodwin, historian and Pulitzer Prize-winner for No Ordinary Time, *her account of the Roosevelt White House during World War II, autographs books after a lecture sponsored by the Chautauqua Literary and Scientific Circle.*

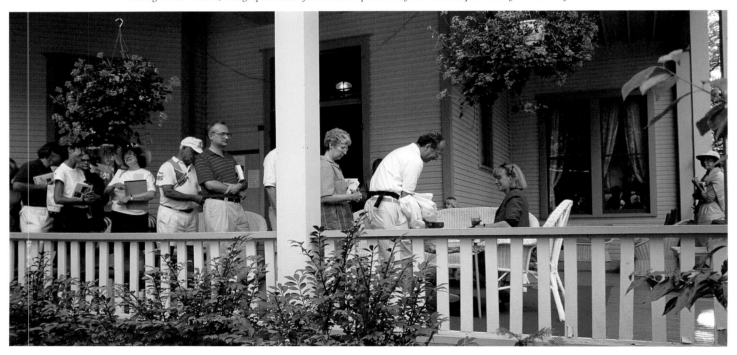

The Ballad of Baby Doe *by Douglas Moore at the Chautauqua Opera with Joyce Castle as Augusta Tabor and members of the Chautauqua Opera Young Artists' Program.*

*CLSC graduates walk through the Golden Gate in 1996
at the 115th Recognition Day ceremony.*

*A Chautauquan and her daughter on the porch of their Miller Park cottage,
just a few feet away from where the first assembly took place in 1874.
The wicker furniture, the board-and-batten siding, and the vase of gladiolas
are basic components of life in Old Chautauqua.*

Opposite: The Chautauqua Dance Company performs under the direction of Jean-Pierre Bonnefoux.

Overleaf: A lifelong Chautauquan and her niece pause by the neoclassical pillars of the Hall of Philosophy.

BIBLIOGRAPHY

There are two books without which this one could not have been written. *Chautauqua* by Theodore Morrison (University of Chicago Press, 1974) and *Three Taps of the Gavel: Pledge to the Future* by Alfreda Irwin (Chautauqua Institution, 1987) are thoroughly researched examinations of the history of The Chautauqua Institution. Because of the time in which *Chautauqua: An American Utopia* had to be produced and because of the extent of the detail in these two earlier works, I relied on them for facts in many cases. This is usually noted in the text, but the debt still must be gratefully acknowledged.

Some other sources were:

Case, Victoria, and Robert Ormond. *We Called It Culture.* New York: Doubleday, 1948.

Cowden, Robert H. "The Chautauqua Opera Association, 1929–1968. An Interpretive History." Typescript monograph. Smith Library, Chautauqua.

Cram, Mary Frances Bestor. *Chautauqua Salute: The Bestor Years.* Chautauqua: Chautauqua Institution, 1990.

Gould, Joseph E. *The Chautauqua Movement.* Albany: State University of New York, 1961.

MacLaren, Gay. *Morally We Roll Along.* Boston: Little, Brown, 1938.

McCullough, David. "Chautauqua and Its Place in American Culture." Speech delivered at Chautauqua, August 9, 1993.

Richmond, Rebecca. *Chautauqua: An American Place.* New York: Duell, Sloane and Pearce, 1943.

Simpson, Jeffrey. "Utopia by the Lake." *American Heritage.* August 1972.

———. "Chautauqua: New York State's Enduring Cultural Community." *Architectural Digest.* June 1986.

Vincent, John Heyl. *The Chautauqua Movement.* Boston: Chautauqua Press, 1886.

Wells, L. Jeanette. *A History of the Music Festival at Chautauqua Institution, 1874–1957.* Washington, D.C.: The Catholic University of America Press, 1958.

I also read extensively in the archives of *The Chautauquan Daily.*

INDEX

Page numbers in *italics* refer to illustrations and captions.

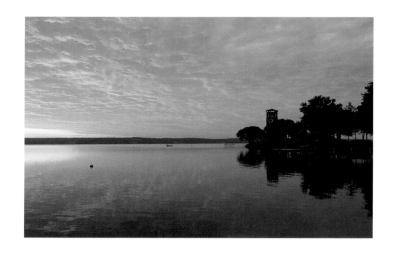

THE CHAUTAUQUA INSTITUTION

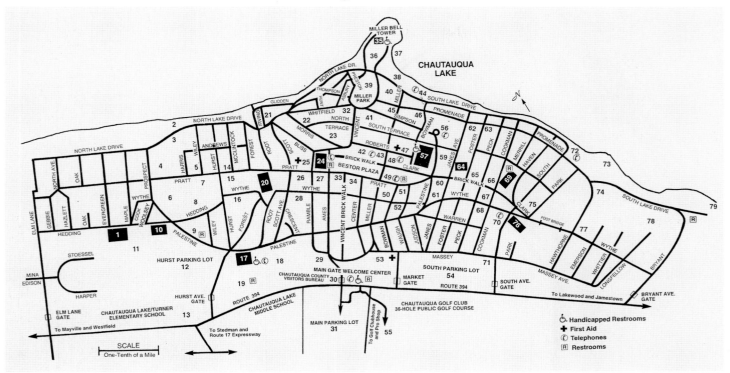

1	Bellinger Hall
1	Summer Schools Dormitory
2	University Beach
3	President's House
4	College Hill Park
5	Mary Willis House
6	School of Art (Arts Quadrangle)
7	Children's School
8	Sheldon Hall of Education
9	Sherwood Piano Studio
10	School of Dance (Carnahan-Jackson Studios)
11	Lincoln Dormitory
12	Hurst Avenue Parking Lot
13	Theater Conservatory Rehearsal Studio
14	Jewett House
15	Vanderbeck Chapel
16	Cinema (Higgins Hall)
17	Lenna (Elizabeth S.) Hall
18	McKnight Hall
18	National Federation of Music Clubs Building/Music School Office
18	Connell Voice Studio
19	Practice Studios
20	Normal Hall
20	Norton Hall
21	Florence Hall
21	1 Root Avenue
21	Gleason Hall
22	Chautauqua Inn
23	Tally Ho Hotel
24	Automatic Teller Machine (Colonnade Lobby)
24	Bestor Plaza

24	Carnahan's
24	Chautauqua Beauty Shop
24	Colonnade Building
24	Customer Service
24	Ticket Office
24	Eckerd Drugs
24	Group Sales Office
24	Kopper Korner
24	Unicorn Antiques Shop
24	Valone's Shoes
25	Chautauqua Police Dept./First Aid
25	Chautauqua Utility District
25	Water Filtration Plant
26	Hurlbut Church
26	Kellogg Hall
27	Aurum Jewelers
27	Bailey's Antiques & Interiors
27	Mary Ann's Jewelry
27	Sadie J's Cafe & Deli
27	Shenango Inn
27	Summer Gallery
28	Chautauqua Center for the Visual Arts Galleries & Gifts
28	Shenango Inn
29	Tennis Courts
30	Chautauqua County Visitors Bureau
30	Customer Service
30	Handicapped Assistance
30	Information Office
30	Main Gate Welcome Center
30	Ticket Office
30	Will-Call Office

31	Main Parking Lot
33	Art Nook at Pat's—St. Elmo
33	Emporium—St. Elmo
33	Food for Thought—St. Elmo
33	Park Grille at the St. Elmo
33	Pat's at Chautauqua—St. Elmo
33	St. Elmo Condominiums
34	Logan Dormitory/Galleries
34	Christian Science Headquarters & Church
35	Fishing Dock
35	Miller Bell Tower
35	Pier Building/College Club/Beach
36	Sample Playground
37	Children's Beach
38	Palestine Park
39	Lewis Miller College
39	Arcade
39	Miller Park
40	Lawn Bowling
41	Albion Guest House
42	Chautauqua Bookstore
42	The Chautauquan Daily
42	Post Office
43	Refectory
44	Central Boat Dock
44	Shuffleboard
44	Sports Club
45	Grange
46	Wensley House
47	Health Clinic/First Aid
47	Ministers' Union

47	Unity Church Denominational House
48	Chautauqua Music
48	CLSC Veranda
48	United Church of Christ Headquarters
48	Viking Trader
49	Library (Smith Memorial)
50	Maple Inn
50	United Church of Christ House
51	United Methodist House
52	Cary Cottage Hotel
52	Rhapsody's Cafe
53	Farmers Market
53	Fire Dept./First Aid
53	Jamestown Cycle Shop (Bicycle rental)
53	Jim's Diner
53	Lost and Found
53	Soap Opera Laundromat
54	South Parking Lot
55	Chautauqua Golf Course & Pro Shop
56	Athenaeum Hotel
56	Sarah's Gift Shop at the Athenaeum
57	Amphitheater
57	Roblee Memorial Garden
57	Screen House/Lecture Audiotape Sales
59	Presbyterian House
60	Disciples of Christ Greybiel House
60	Disciples of Christ Headquarters
61	Gingerbread Cottage

61	Lincoln Park
61	Spencer Hotel
62	Women's Club
63	Bishop's Garden
63	Hukill-Lacey Cottage
63	32 South Lake Drive
63	United Methodist Missionary Home
64	Baptist House
64	Smith-Wilkes Hall
65	Episcopal House
66	Lutheran House
66	McConnell House
67	Hall of Missions
68	Octagon Building
68	Pioneer Hall
69	Hall of Philosophy
70	Alumni Hall
71	Opera Rehearsal Building
72	Heinz Beach/Bath House
72	Youth Activities Center
72	Beeson Youth Center
72	Boys' and Girls' Club
73	Seaver Gymnasium
73	Volleyball
74	Sharpe Field/Softball
75	Episcopal Chapel of the Good Shepherd
76	Hall of Christ
77	Fenton Memorial Deaconess Home
78	Basketball Court
78	Tennis Courts
79	Coyle Pavilion
79	Boat Ramp

PHOTOGRAPH CREDITS

All of the historical photographs used in this book come from the archives
of The Chautauqua Institution.
Courtesy of The Chautauqua Institution Archives, Chautauqua, New York: 30, 35, 36, 38,
39, 40, 41, 42(2), 43(2), 44, 46, 49, 50, 51, 52, 53(2), 54, 56(2), 57, 58, 59, 61, 62, 63(3), 66,
68(2), 69, 70(3), 71, 72, 74–75, 79, 80, 82–83, 84–85, 87, 92, 93, 94, 95, 96–97, 98–99, 100(3),
101(2), 103(2), 107, 109.

The Chautauqua Institution: front cover, 2–3, 6–7, 22–23, 119 above, 120 below, 128.

The Chautauqua Institution / Andrew J. Dickson: 111 above, 114, 118, 119 below, 121 left.

The Chautauqua Institution / Ken Howard: 120 above.

The Chautauqua Institution / Paul Solomon: back cover (above left, center left, below left,
above right, below right), 1, 4–5, 8, 10, 11, 13(2), 14–15, 16, 18(2), 19, 20(2), 24, 27(2),
28(2), 29, 55, 64, 65(2), 76–77, 104, 111 below, 122, 124.

The Chautauqua Institution / Tom Wolf: back cover (center right), 24–25, 108, 121 right.

Margaretta Barton Colt: 107.